IMAGES
of America

PERTH AMBOY

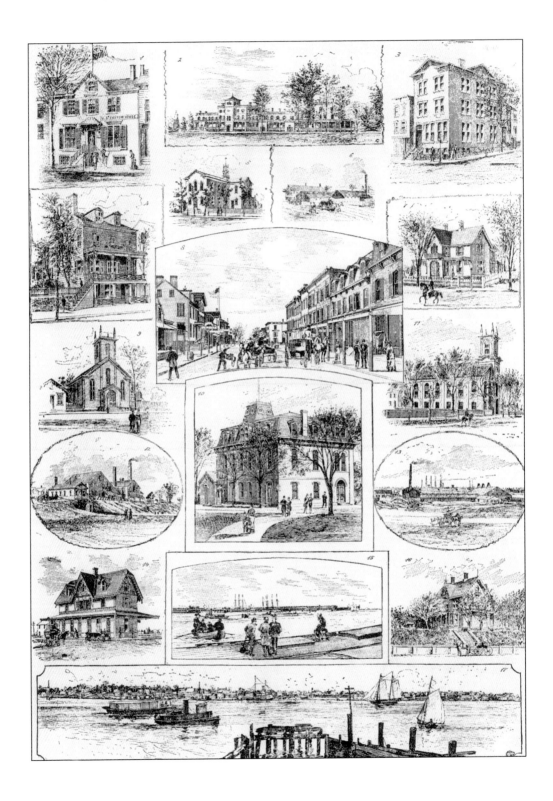

IMAGES
of America

PERTH AMBOY

Joan Seguine-LeVine

ARCADIA
PUBLISHING

Published by Arcadia Publishing
Charleston, South Carolina

Printed in the United States of America

For all general information contact Arcadia Publishing at:
Telephone 843-853-2070
Fax 843-853-0044
E-Mail sales@arcadiapublishing.com
For customer service and orders:
Toll-Free 1-888-313-2665

Visit us on the Internet at www.arcadiapublishing.com

CONTENTS

ACKNOWLEDGMENTS

I thought my task of finding photographic records would be fairly straightforward for a city as old as Perth Amboy. I was wrong. Picking up the trail of the visual footprints tracing Perth Amboy's past is much like putting together a jigsaw puzzle whose pieces have no identifying picture on the box, no number of pieces, and most difficult of all—no box. Without help I would not have been able to compile this record. I am grateful more than words can say, and will proceed philosophically, "Two hundred and twenty-eight pictures are worth more than 28,000 words." Thank you to all.

Ila Ginzberg Miller's fascination with the mapping of the city, the way the land was plotted, and the mysteries of this place, combined with her support and patience and willingness to walk, talk, and think about Perth Amboy, sustained my own enthusiasm for the project; Joyce Yaffe, Lena Ginzberg, and Betty Ward of The Crystal Shoppe on High Street, which served as our "Command Control Center," contributed ideas, names, people to talk to, information, and gave me a place to work from; Sylvester White introduced me to Charlie White, one of Perth Amboy's treasures. Charlie has been my companion in this search as well as the Eagleswood project; Jim and Joan Hardiman were valuable sources of identification, information, and endless cups of tea at Seaman's Drug Store, another Perth Amboy institution; former mayor George Otlowski Sr. helped identify many people in photographs and enriched my understanding of Perth Amboy; Frank Premako at Acme Studio, a skillful photographer, carefully printed hundreds of photographs from old negatives, copying and restoring them to better condition than the originals; Barbara and Lou Booz of the Maid of Perth contributed photographs, postcards, and identifications; Veronica Smith and Connie Stoltenberg provided First Presbyterian Church photographs; the Perth Amboy Public Library and Patricia Gandy's staff of Herschel and Eddie were cooperative and helpful, continuing the fine library tradition of Perth Amboy; John V. Burns, Esq., contributed many recollections and stories, which were enhanced by his understanding of Perth Amboy and his obvious depth of feeling for the city; Eloise Rudman of the YMHA searched the archives of the "Y"; Steve Welch of the YMCA contributed scenes of the early YMCA; Austin Gumbs suggested people to talk to, shared little-known facts, and opened up many possibilities; Nancy Duschock at the board of education allowed me to borrow the school scenes; Rose Galvin contributed stories, as well as photographs of baseball teams, people, and schools; Helen Dudash, whose husband Steve owned a photography studio in Perth Amboy, shared many of these photographs and many recollections of the Hungarian community; Howard Palmer let me borrow a photograph of a Lehigh Valley Railroad engine and gave information about Perth Amboy churches; Reverend Davis of the St. James AME Zion Church contributed photographs and information on the church's history; and finally, I would like to thank Newton LeVine, who patiently endured my numbering system as he laid out the book. He has given his talents and abilities as a graphic designer to make this book visually interesting.

INTRODUCTION

I was born in Perth Amboy. I grew up here. I went to school here. Eventually, I moved on, as did many others, including those who made their fortunes from the town's resources and industrialization. That was not my experience. But I have come to appreciate what I did receive—a sense of community, of belonging, of people knowing who you are. I hope that you see in this photobiography a city of exciting beginnings, opportunities, and resources.

In 1600, the Lenni Lenape tribe of Native Americans were the first settlers on the land where the waters of the Raritan River and the Arthur Kill Sound meet. The Lenape knew this area as Ompoge, meaning "elbow" or "point" of land. Here they fished, made pottery, and traded. The Dutch came to Perth Amboy in 1623. On December 8, 1651, the Lenape handed over Ompoge to August Herman, a Dutch trader from Staten Island. The first European settlers were drawn to this area because of its location. Some immigrants—such as the Scottish Presbyterians—came seeking religious freedom.

Early historians were sure that Ambo, as it was called by the original residents, was derived from Emboyle, as recorded on a 1665 deed. It became Amboyle in 1666. Scotland's James, Earl of Perth, one of the early proprietors, contributed the Perth.

Agents of the East Jersey Proprietors, a governing board that still meets today, noticed Amboy Point as a "sweet, wholesome and delightful place." It was a good place "for merchandise, trade and fishery." They laid out the city, took and divided the 1,500 acres of Ambo Point into 150 lots of 10 acres each, and resolved to build "by the help of Almighty God with all convenient speed, a convenient town."

In 1686 the Provincial Assembly met in Perth Amboy; by 1688 the city had two representatives in the assembly, was a port of entry, and was on its way to becoming a city—the capital of East Jersey.

Perth Amboy prospered in the pre-Revolutionary War years. There were trees and meadows and pure water. The rich and the famous made their homes here. Governor William Franklin, son of Benjamin Franklin, lived in the Proprietary House. However, by 1794, Perth Amboy had lost its place as one of the most important towns in the Colonies and was no longer the capital of East Jersey.

At the beginning of the nineteenth century, Perth Amboy re-invented itself as a resort town. The Proprietary House became the Brighton House in 1808, and was a popular hotel with the rich and those taking the cure at Perth Amboy's spas. In the years before the Civil War, a Utopian community surveyed by Henry David Thoreau attracted the nation's intellectual, cultural, and artistic elite. Guided by abolitionist and suffragist beliefs, the Raritan Bay Union (in a settlement known as Eagleswood) initiated an experiment in changing the existing concepts of work, economy, and education. Its school, with concepts far ahead of the times, was an attempt to even out inequities and to make life more fulfilling for all races, classes, and genders.

How Perth Amboy's Utopian, Indian, Proprietary, Colonial, and pre-Civil War faces were forever transformed into a gritty, industrial reality is a compelling story. The end of the Civil War and the modern transportation and manufacturing methods of the Industrial Revolution brought factories to Amboy Junction. These industries were attracted by the city's harbor, the waters of the Raritan, and rich deposits of clay. Natural deposits of fire clay and kaolin were used by five terra-cotta industries, and Perth Amboy soon became a ceramics center. Terra-cotta products from Perth Amboy still adorn buildings all over the world.

In 1876, the Lehigh Valley Railroad entered Perth Amboy from the west, bringing coal from Pennsylvania and making the city its tidewater terminus. The Central Railroad of New Jersey, the Pennsylvania Railroad, and the Staten Island Rapid Transit Railroad also serviced Perth Amboy, providing a transportation system described as being better than that of any town in the country. Deep-water docks lined the city's waterfront, enabling freight to be shipped all over the world. Coal wharves were erected.

Coal, which ran industries and heated homes, also brought other industries, such as shipbuilding, to the area. This pattern of one industry initiating another continued. The fine transportation system attracted the powerful Guggenheim and Lewishon interests, which established refineries. Guggenheim made Perth Amboy the world's largest copper manufacturer. Factories were given special inducements and sites near the water could be purchased at very low rates. Thousands of rolls of roofing paper and the world's supply of Vaseline products were made in Perth Amboy by the Chesebrough Manufacturing Company. Wire and cable rolled from the Standard Underground Cable Company.

As a port of entry, Perth Amboy attracted a hardworking labor force. The early Scots were followed by the English. Danes, particularly skilled in the making of clay products, journeyed here. The Irish settled near the waterfront and helped to build railroads and load coal. Germans followed. Italians, Greeks, and Jews came along with Poles and Hungarians. French, Slavs, South Americans, Mexicans, Puerto Ricans, and Finns arrived later.

In 1910, it was inexpensive to live and do business in Perth Amboy. The economic climate was favorable. Tax rates were low, rentals were affordable, and housing was plentiful. Perth Amboy had superior utilities. The schools were outstanding. Churches of all denominations rose up. Once again Perth Amboy was thriving.

Unfortunately, this prosperity eventually declined. Large manufacturers left in response to stringent government regulations. Tax incentives expired, leaving no economic reason to remain. Labor costs were lower in other countries. The immigrants, having been welcomed and educated, left seeking more lucrative opportunities. The malls came. Perth Amboy lost its center.

Much of the Golden Age of Perth Amboy has been lost—the old buildings, the shops, and the historic homes have vanished. The factories are skeletons. Perth Amboy is now part of the "Rust Belt," an aging, faded industrial region. The city sometimes seems a wavering reflection of times when smoke billowed from the smokestacks, when jobs were plentiful, when Smith Street was thronged with Friday night shoppers jostling for a place on the crowded sidewalk. But the future promises rejuvenation. The natural resources of the harbor, the bay, and the river remain. The waters are clearing and the fish are swimming once again. There are shoppers on the streets and concerts by the bay.

This is the story of Perth Amboy's heritage, a photographic record of a time and a place. It is also the story of Perth Amboy's present and future. Most of the images shown were photographed between the years 1876 and 1966. The images reveal the feistiness of Perth Amboy—its spirit. I hope they reflect what it was like to grow up, to go to school, to work, and to build a life in a "sweet, wholesome, and delightful place."

One

THE RARITAN RIVER

Portus optimus

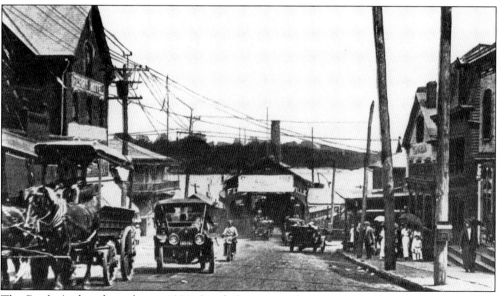

The Perth Amboy ferry slip, *c.* 1900. Smith Street was the main artery from the shore to New York until the Outerbridge Crossing and the Holland Tunnel were built in the 1920s. John D. Rockefeller, among many others, waited in his automobile in the line for the Perth Amboy to Staten Island Ferry; he handed out small change to waiting Perth Amboy youngsters. On the left is the Ferry Hotel.

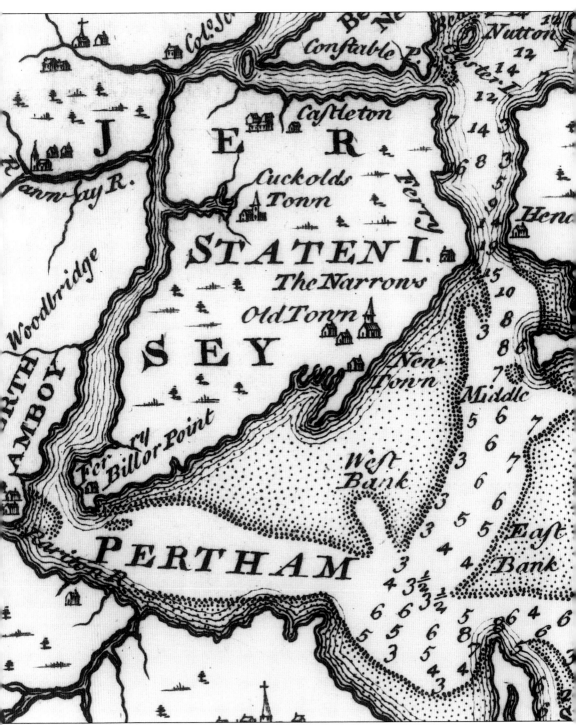

An early cartographer's draft of Perth Amboy Harbor, c. 1700. Perth Amboy's beginnings were focused around the Raritan River and the bay. Indians ate fish and shellfish from these waters, piling clam and oyster shells high along their villages on the banks. Records from as far back as 1600 tell of the annual spring custom of early European settlers traveling up the river to trade

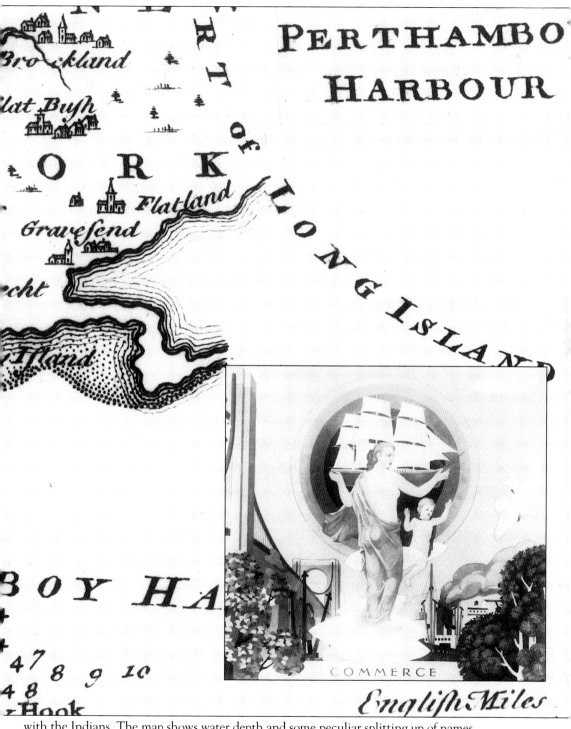

with the Indians. The map shows water depth and some peculiar splitting up of names.
Insert: One of the McGinnis School murals, 1935–38. *Commerce*, a 12-by-14-foot painting by artist Karl Lilla, is at the right of the stage.

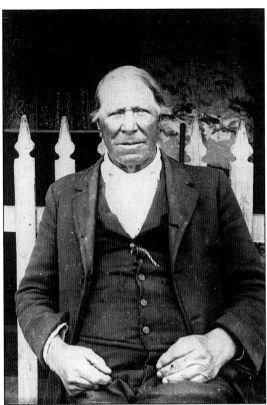

Ferryman James Seguine, *c.* 1893. The river determined early professions. Workers were oyster openers, ship carpenters, sailmakers, and oystermen. James, photographed in front of his home at 107 Front Street, was employed as a ferryman and bridge tender.

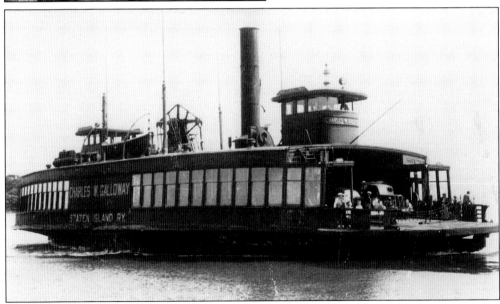

The *Galloway, c.* 1948. Captain James E. Lane steered the *Galloway* on the seven-minute trip across the Arthur Kill between Perth Amboy and Tottenville. For forty-two years, the *Galloway* or the *Perth Amboy* ferried hundreds of commuters daily and transported many others who made the ride just to relax, listen to accordion music, and enjoy the feeling of a ferryboat under their feet.

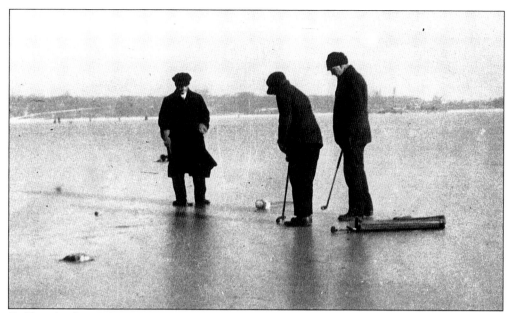

Golf on the frozen Raritan, 1918. In the winter of 1918, the river was frozen so solid that golfers were able to practice putting without a greens fee.

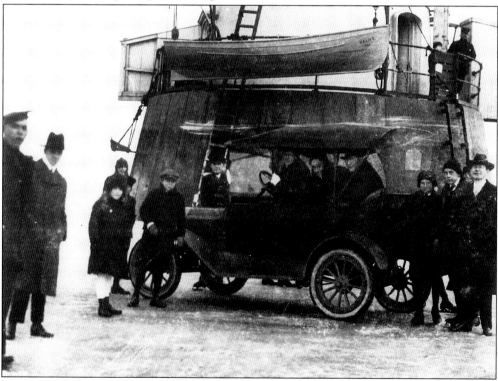

The Great Beds Lighthouse, Christmas Day, 1917. The lighthouse was a landmark in Raritan Bay. It was completely surrounded by water, and marked the location of oyster beds in the 1880s. During the cold freeze of 1917–18, the waters off Perth Amboy were frozen all the way out to the lighthouse.

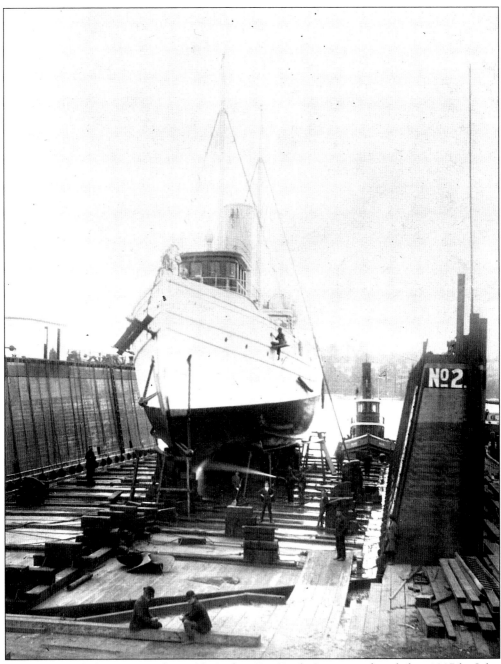

A ship in dry dock, *c*. 1900. The Perth Amboy Dry Dock Company, founded in 1887 by John Runyon to repair marine railway ships, doubled its size in 1918 when it purchased the Raritan Dry Dock Company. The company built tugboats, carfloats, and barges; beginning in the 1930s, it also repaired ships.

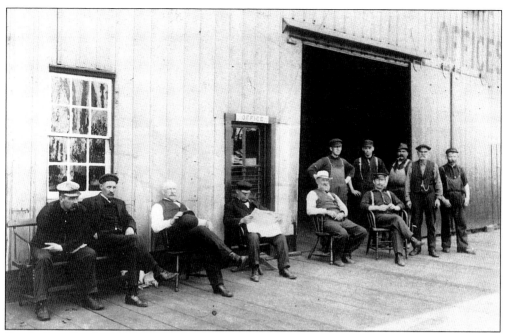

Dry dock staff at the foot of Broad Street, c. 1918. In 1899, Axel Olsen found work as a timekeeper for the Perth Amboy Dry Dock Company. He then became a bookkeeper, purchasing agent, and treasurer. He was elected president of the company in 1936.

Watching a ship being launched, c. 1897. Activity on the water created an occasion for spectators, who always went to see what kinds of boats had docked, were in for repair, or were about to be "hauled out."

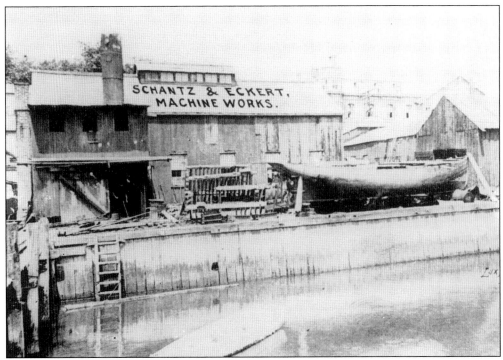

Schantz & Eckert, c. 1906. A manufacturer of marine engines, this machine shop built some of the machinery for the *Holland*, the U.S. Navy's first submarine.

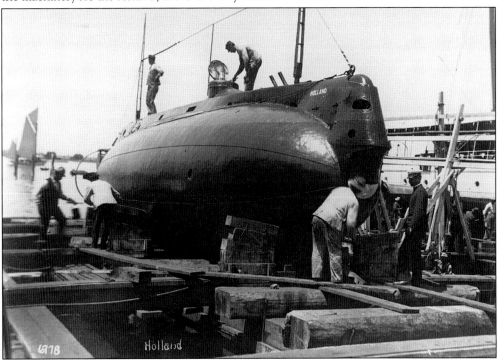

The *Holland*, c. 1900. The *Holland*, invented by John P. Holland, was first tested by Schantz & Eckert in Raritan Bay.

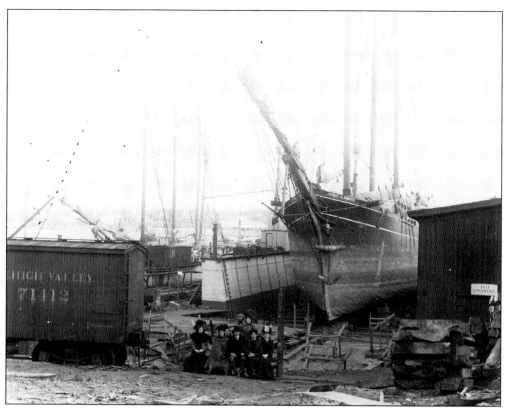

A Lehigh Valley Railroad car and dry dock. Perth Amboy's location attracted Asa Packer, the owner of the Lehigh Valley Railroad, who was searching for a railroad right-of-way to get coal to the Hudson River/Upper New York Bay waterfront. Coal ran Perth Amboy's industries, and each factory had its own railroad siding.

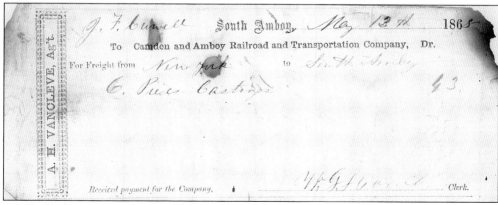

A bill of lading, May 13, 1868. Perth Amboy's harbor was exalted in a pamphlet distributed to railroad and financial interests. The pamphlet read: "The harbor is not obstructed by ice in the winter . . . the freight and passage boats of the Camden and Amboy Railroad ran to and from New York the whole winter of 1855–56, when even the Chesapeake Bay, and many others were for a long time closed by ice."

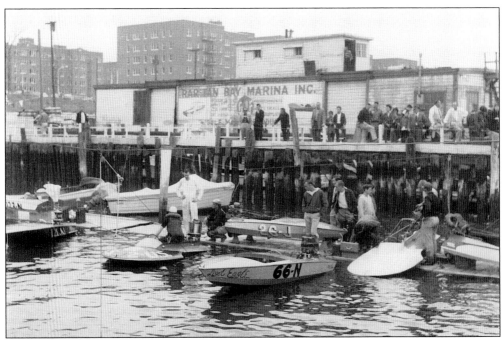

A marina, c. 1960s. The Raritan was a source of recreation for sailing, fishing, and racing.

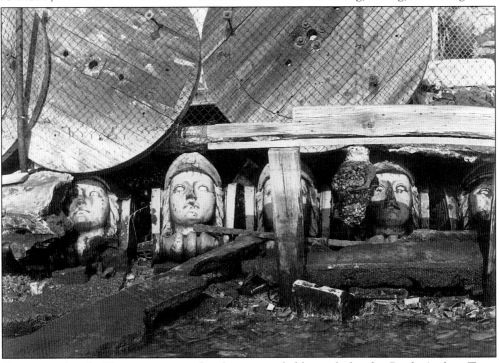

Terra-cotta heads. These terra-cotta heads were probably made by the Perth Amboy Terra Cotta Works to replace cornices destroyed in the San Francisco earthquake. The heads were chipped and when Buckingham Avenue began to collapse, somebody took the heads and used them to shore up the buckling road.

The Booz Dock, 1953. Built by Louis Booz, Perth Amboy's city engineer, the cupola was an important structure on the waterfront. The gardens were planted by Rose Booz.

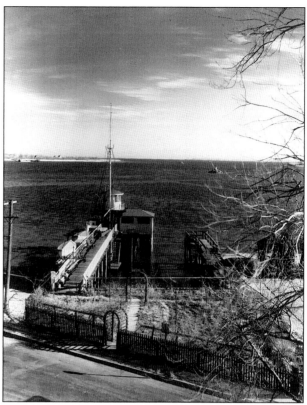

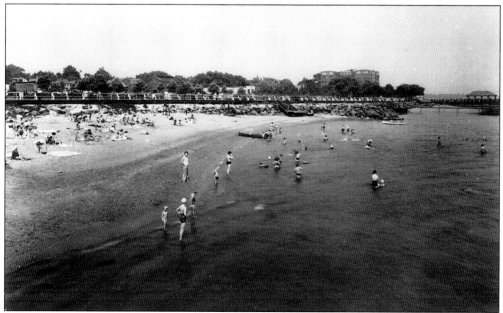

A bathing beach on the south shore, July 25, 1941. The warm waters of the river made summer in Perth Amboy bearable. For citizens in the midst of saving gasoline and rubber tires during World War II, the boardwalk lined with benches, the pavilion stretching out into the river, and the coarse sand beaches set the scene for a needed respite.

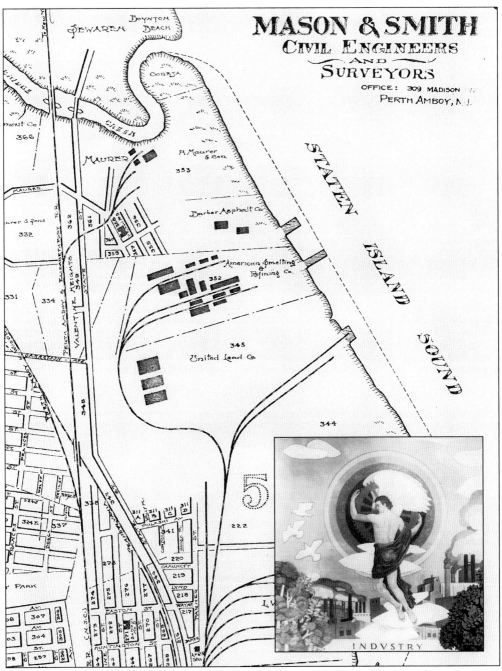

Richmond's City Directory Map, 1918. The area marked as "5" shows industrial development related to the river. In the northeast, Maurer was a town unto itself named for Henry Maurer, a brick manufacturer. For seventy-five years, Maurer had its own post office; the town eventually came to be called "Barber."

Insert: The McGinnis School mural *Industry*, 1935–38. All of the McGinnis School murals, busts, and tablets were WPA projects authorized by the board of education under the recommendation of Dr. W.C. McGinnis.

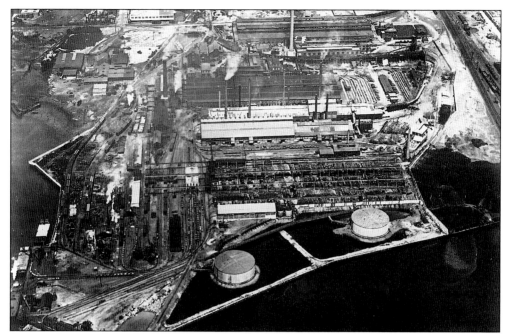

An aerial view of the Copper Works, c. 1937. The berthing facilities handled eight to ten barges at a time delivering blister copper and exporting refined copper. Looking carefully, you can see part of the of the 20-mile narrow-gauge railroad connecting the factory's buildings. In the background you can see the field where Babe Ruth hit a ball that landed on First Street.

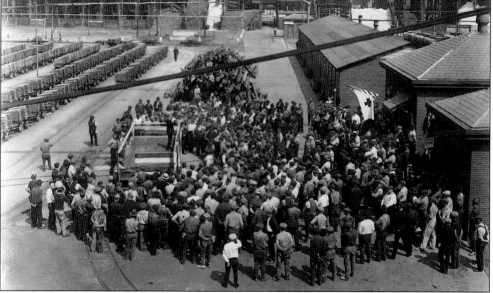

The Raritan Copper Works, c. 1940s. The Lewishohn brothers established the Copper Works in 1898 at the foot of Elm Street, close to the railroad tracks. Immediately, it became the largest electrolytic copper refinery in the world. The Raritan Copper Works employed 2,500 in 1935 when it merged with the International Smelting and Refining Company. It achieved industrial recognition initially by refining copper, and went on to produce giant copper cakes and sheet copper for electronic instruments.

The Perth Amboy Dry Dock Company, *c*. 1950s. A vessel coming in for repair would be brought into the company's docking facility at the foot of Commerce Street and the Arthur Kill. The dry dock would be flooded and the ship raised and settled into place for the necessary work.

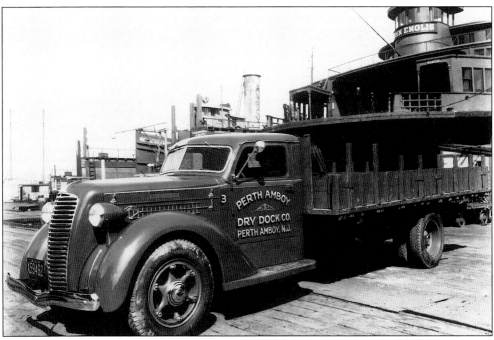

A Perth Amboy Dry Dock Company truck, *c*. 1940s. A ferry waits in back of the company truck. When the company was organized in 1887, it served three-masted schooners. Barges, tugs, and commercial vessels were later customers.

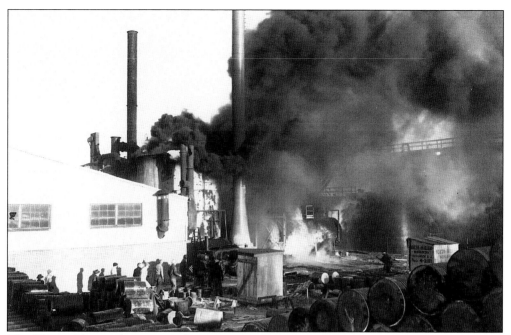

The Witco Chemical Company fire. A story about Robert Wishnick, the founder of Witco Chemical Company, tells of his attempts to formulate a floor wax compound while working at his first job. He had a mixture of wax and turpentine on the Bunsen burner when the telephone rang. Answering the call, he became distracted. The building and the warehouse next to it burned to the ground.

The Witco Chemical Company. Witco will long be remembered for its contributions to Perth Amboy.

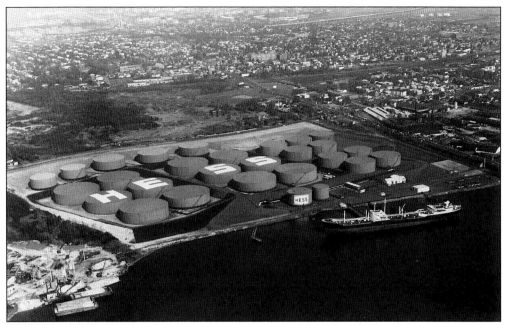

Hess tanks along the waterfront. Hess Oil was begun by Leon Hess' father. It started small with three or four employees—a manager, an engineer, and a dispatcher who operated an oil delivery route from the town known as Maurer.

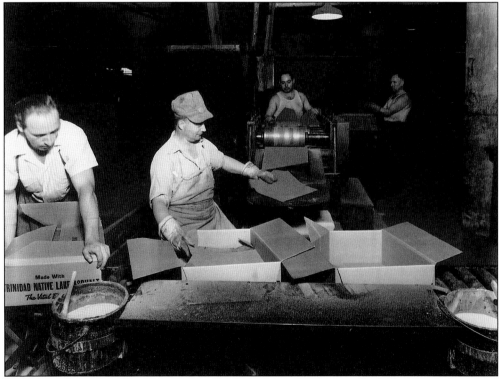

Packing asphalt shingles. The Barber Asphalt Paving Company built huge refineries and manufacturing facilities. They manufactured asphalt shingles and rolls of roofing paper.

An ad for Chesebrough products. Brand name recognition was a marketing issue in 1935 too. This advertisement cautions buyers not to trust druggists' claims about other petroleum jellies, and touts the quality product identified by Vaseline's blue seal. The company's founder believed in swallowing a tablespoon of Vaseline daily. He lived into his eighties.

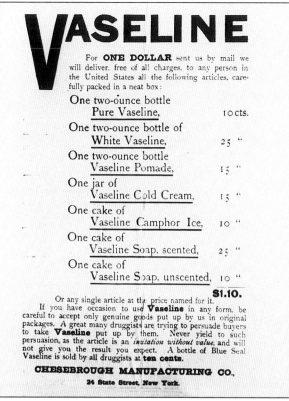

VASELINE

For **ONE DOLLAR** sent us by mail we will deliver, free of all charges, to any person in the United States all the following articles, carefully packed in a neat box:

One two-ounce bottle Pure Vaseline,	10 cts.
One two-ounce bottle of White Vaseline,	25 "
One two-ounce bottle Vaseline Pomade,	15 "
One jar of Vaseline Cold Cream,	15 "
One cake of Vaseline Camphor Ice,	10 "
One cake of Vaseline Soap, scented,	25 "
One cake of Vaseline Soap, unscented,	10 "
	$1.10.

Or any single article at the price named for it.

If you have occasion to use **Vaseline** in any form, be careful to accept only genuine goods put up by us in original packages. A great many druggists are trying to persuade buyers to take **Vaseline** put up by them. Never yield to such persuasion, as the article is an *imitation without value*, and will not give you the result you expect. A bottle of Blue Seal Vaseline is sold by all druggists at **ten cents**.

CHESEBROUGH MANUFACTURING CO.,
24 State Street, New York.

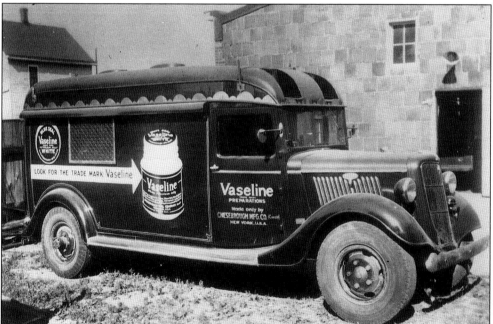

A Vaseline truck, *c.* 1930s. The Chesebrough Manufacturing Company made Vaseline for the world from its Raritan River facility. An invoice to the Edison Laboratories records the sale of 25 pounds of red Vaseline #3 to Thomas A. Edison.

A terra-cotta detail from the facade of Canadian Furniture on 224 Smith Street. Perth Amboy sat directly over a very rich deposit of clay and many clay manufacturers located their factories here. The list included: Henry Maurer & Sons (a brick-making factory on the sound south of Woodbridge Creek), the New Jersey Terra Cotta Company (which merged with other companies to form the Atlantic Terra Cotta Company), and C. Pardee's Brick Factory (at the north end of the Victory Bridge).

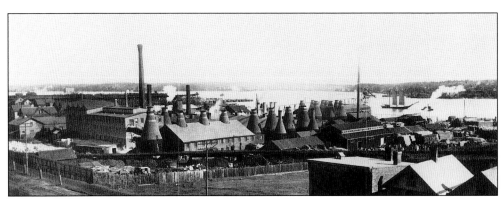

The Perth Amboy Terra Cotta Company. Opened in 1846 and originally known as A. Hall and Sons, this company produced terra cotta and porcelain. Watson's Brick Factory (next to the Raritan Copper Works), Hall's Terra Cotta Company (west of High Street), and the National Fireproofing Company (west of Pardee's under the Driscoll Bridge, for whom my grandfather worked) were other area clay manufacturers.

Entire Roof Of $11,500,000 Supreme Court Building Was Made In Perth Amboy

10-7-35

Residents of Perth Amboy should be much interested in the $11,500,000 United States Supreme Court building in Washington in which the Supreme Court will convene for the first time today, William H. Powell, president of the Atlantic Terra Cotta Company, said in an interview this morning.

The entire roof, several acres in extent, of this dignified monumental structure, designed by the distinguished Architect Cass Gilbert, is of terra cotta tile made in the company's High street plant from Middlesex county clays. These tiles are the Greek pan

ly right, and during the fabrication of the work Mr. Gilbert visited Perth Amboy and studied color effects of various glazes for an entire day. I was finally determined to make a considerable quantity of the tile in various colors and shades, and these were set up on the roof in actual position, the exterior of the structure by that time having been completed. Mr. Gilbert and Mr. Powell made a special trip to Washington and inspected the result from the top of the Congressional Library. At that time the final decision as to color of the glaze was made, the selection being

A headline of October 7, 1935. Perth Amboy's terra cotta was used from coast to coast.

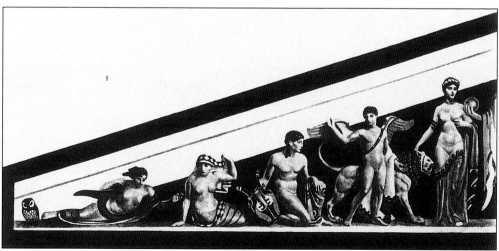

A detail of the tympanum for the Philadelphia Museum of Art, C. Paul Jennewein, sculptor. The Atlantic Terra Cotta Company attracted international attention for its use of brilliant polychrome and gold glazes. The work consists of thirteen free-standing figures 70 feet wide and up to 12 feet high. New methods of manufacture were developed for this project in the company's Perth Amboy waterfront plant.

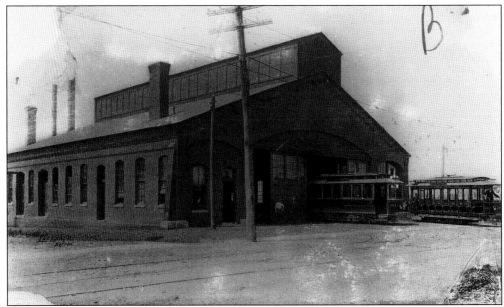

The Raritan Traction car house, *c.* 1915. The block-long "car barn" ran between Davidson and Bertrand Avenues and housed the trolleys of the Raritan Traction Company. This was the first trolley company to hold a franchise in Perth Amboy. Later this building garaged the Public Service Coordinated Transport buses.

The opening of the new railroad station. In 1923, contracts were awarded for the construction of a new railroad station that required the building of five bridges. This was intended to prevent another catastrophe such as the one that occurred on June 15, 1921. The crossings at grade were a hazard for vehicles and pedestrians.

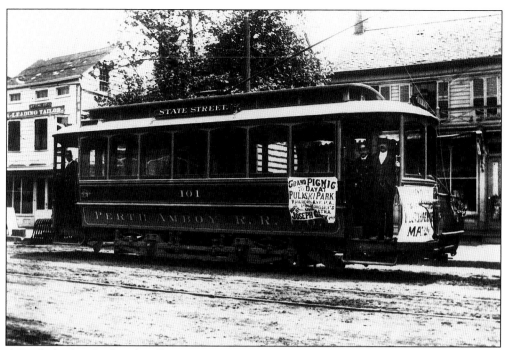

A Perth Amboy Railroad trolley, *c.* 1900. Trolley cars were the means of transportation for the average Perth Amboyan. The Raritan Traction Company had summer cars and winter cars. Shown is a winter car of the State Street line.

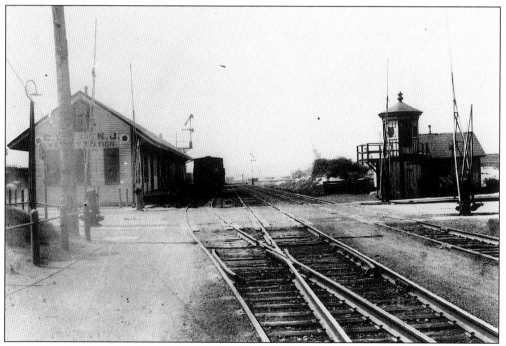

The railroad station at grade. At this Market Street grade crossing of the Central Railroad, nine volunteer firemen from the Eagle Fire Company were killed when their truck collided with a passenger train.

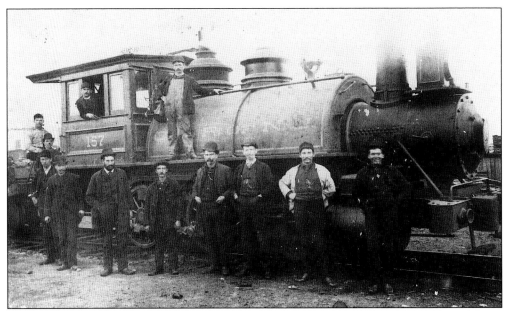

Central Railroad engine no. 157. The Central Railroad operated the New York and Long Branch Railroad from Perth Amboy to Long Branch.

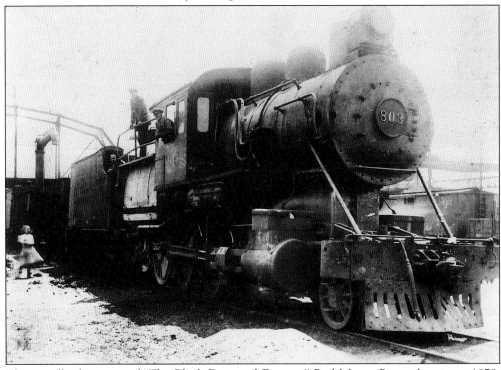

The camelback engine of "The Black Diamond Express," Bethlehem, Pennsylvania, c. 1879. Named for the vast wealth of anthracite in the Lehigh Valley, this train was a fast daylight express. Howard Palmer, who lives in present-day Perth Amboy, has ties with the Lehigh Valley Railroad. His father appears with William Palmer, Howard's uncle, in the cab of the camelback engine, so named because of its double hump.

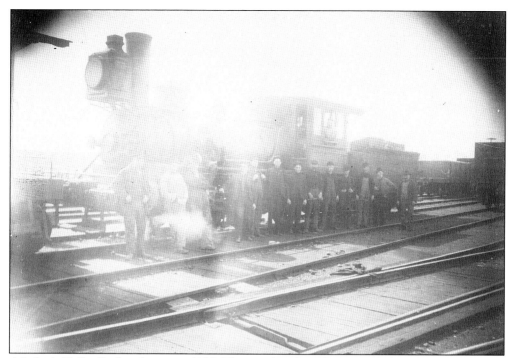

A Lehigh Valley Railroad engine, 1903. These railroad employees include Matthew Burns and John J. Burns, uncle and father of Perth Amboy attorney John V. Burns. At the time there was a railroad station on New Brunswick Avenue at the end of Oak Street.

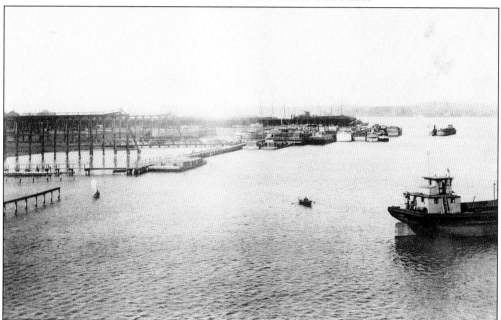

The waterfront and coal docks of the Lehigh Valley Railroad. When Asa Packer and his Lehigh Valley Railroad Company made Perth Amboy its tidewater terminus in 1876, the city's industrial development began. The "Black Diamond Express" brought anthracite coal from Pennsylvania.

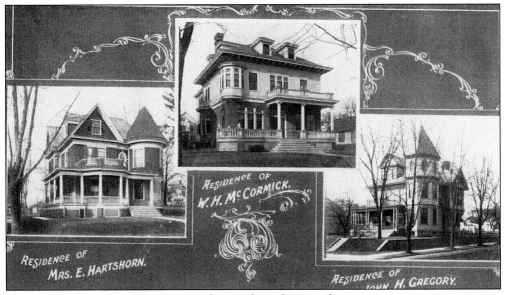

Three prime examples of imposing residences along the waterfront.

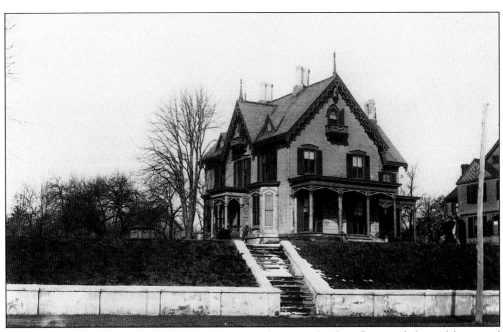

A house on the Bluff. Note the double-hung windows on the first floor and the richly carved and perforated verge boards.

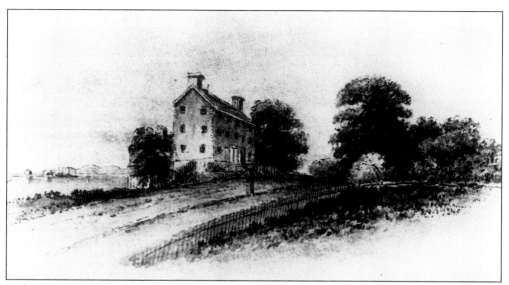

Parker Castle. The Willocks Lane area is one of the oldest in the city. In this historic area, John Parker built Parker's Castle from stone in 1720–22. It stood where Harbor Terrace now stands and was torn down in 1942. This view from north of the castle is from a watercolor.

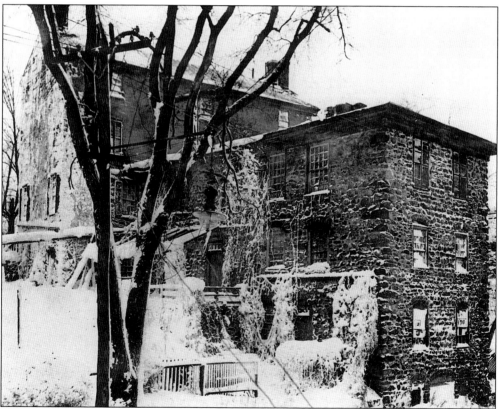

Parker Castle in winter. The castle and its surrounding gardens were used for balls, dinners, and parties. During the Revolution, Parker added a section made of wood. The British Army used the castle for a barracks and sometime hospital. The American Army used it for a hospital.

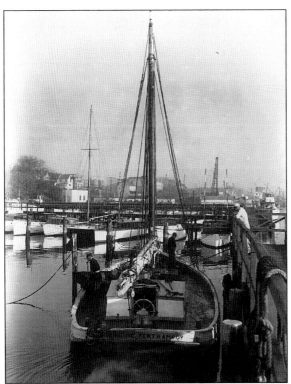

The *Van Name*. The last clam boat out of Perth Amboy was owned by Gus Larsen.

Gus Larsen's house, Front Street. Charlie White remembers the "fastidious Danish housekeeping of the Larsen house with gleaming copper pots and pans hanging in the kitchen" and Mrs. Larsen making sure no one in the neighborhood went without a meal.

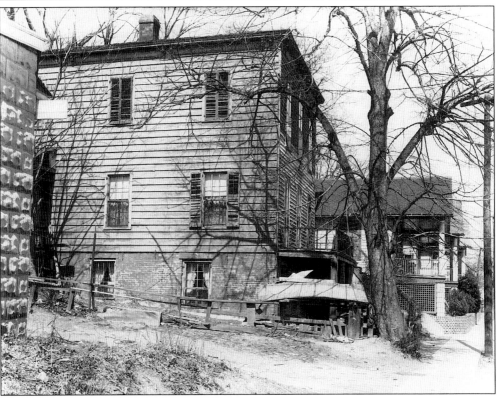

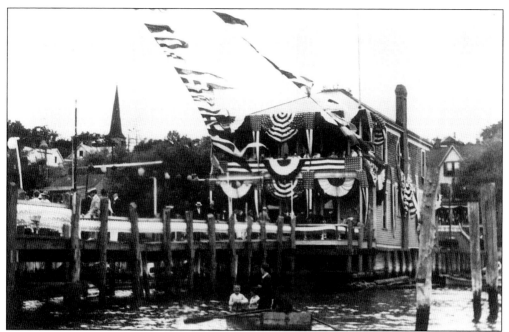

A celebration at the Raritan Yacht Club. The Raritan Yacht Club has a history going back to the Civil War. The first club was the home of Reverend James Chapman, rector of Saint Peter's Church, at the northeast corner of Rector and Gordon Streets. A new club was built in 1906, and was destroyed in a fire in 1915. The present club was built in 1919.

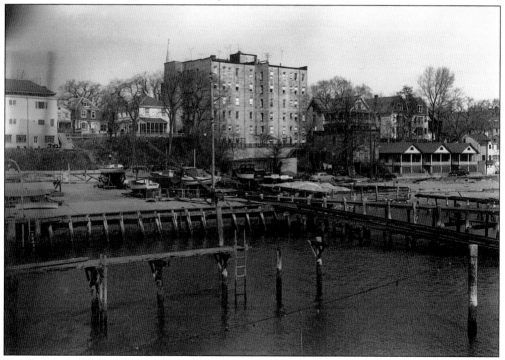

Gus Larsen's dock. The large, brick apartment building in the rear was destroyed by a recent fire.

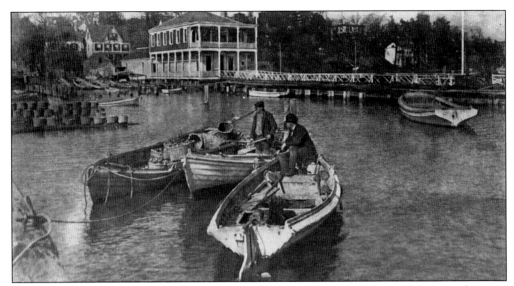

Oystering on the Raritan. Perth Amboy's oysters were prolific and the best. There were frequent oyster bed battles between New York and New Jersey oystermen, based on accusations of raiding. The old Raritan Yacht Club can be seen in the background.

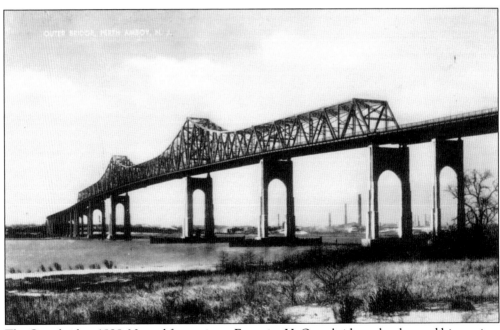

The Outerbridge, 1928. Named for engineer Eugenius H. Outerbridge, who donated his services for the bridge design to the Port Authority of New York, this is Perth Amboy's most recent river crossing. For many years it didn't produce adequate revenue for the Port Authority. The stacks in the right background are those of the American Smelting and Refining's plant on State Street.

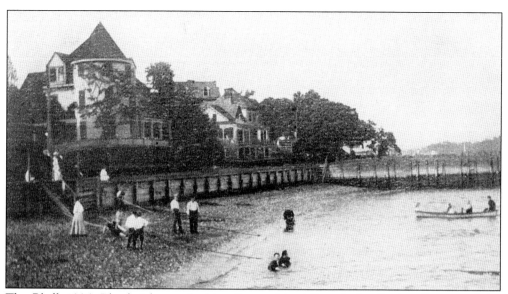

The Bluff, 1906. The height overlooking Staten Island Sound, the Raritan River, and the Raritan Bay was called "The Bluff."

Mrs. Esberg's stand on Water Street, at the foot of High Street, 1941. Mrs. Esberg charged 5¢ to get on the beach and carefully monitored would-be intruders. This food concession was operated by Rose and Max Turtletaub for one year. Rose and Max subsequently became owners of the Army & Navy Store on Fayette Street and Turtle's on Smith Street.

A marine view of Perth Amboy, 1905. The Raritan River attracted romantics of all generations.

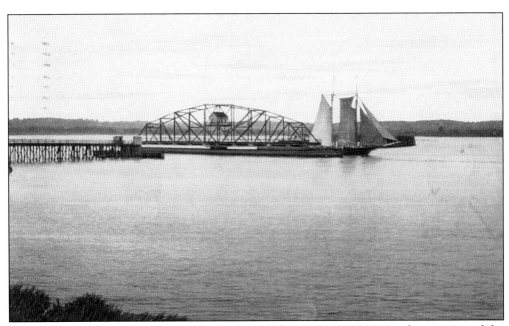

County Bridge, the predecessor to the Victory Bridge, June 19, 1906. At the opening of the wooden drawbridge, factory whistles blew and crowds from South Amboy started across to meet crowds coming from Perth Amboy. Perth Amboy's Mayor Pfeiffer and South Amboy's Mayor Treganovan were to meet in the center. Unfortunately, the draw was off center, a plank split, and the bridge wouldn't close. Rain didn't stop crowds who waited for hours for the opening.

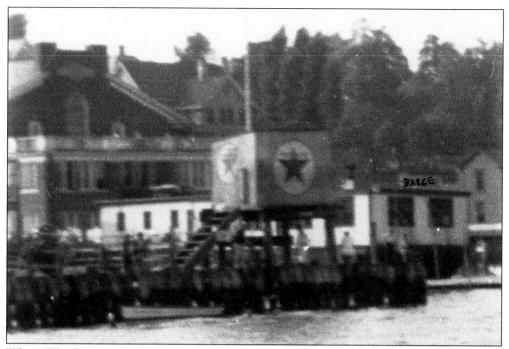

When "The Barge" was a barge, c. 1950s. The original Barge Restaurant was started simply by a man who was living on the vessel at the time. He scooped crabs directly from the Raritan, cooked them on a primitive stove, and served them to waiting customers. This Barge burned in a fire in 1951.

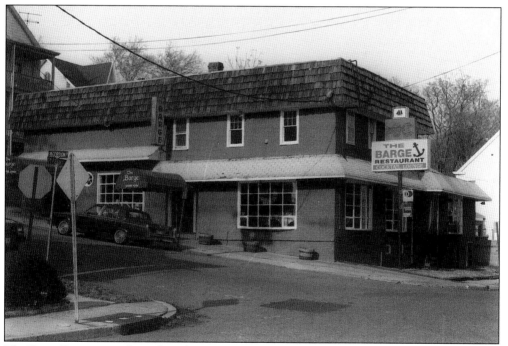

The Barge Restaurant. One of Perth Amboy's favorite restaurants on Front Street is close to the anchorage of the original floating restaurant.

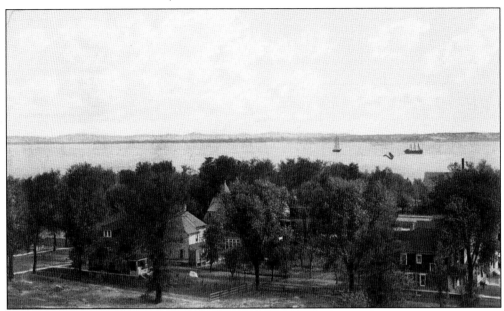

A tranquil river scene. Note the three-masted ships in the background.

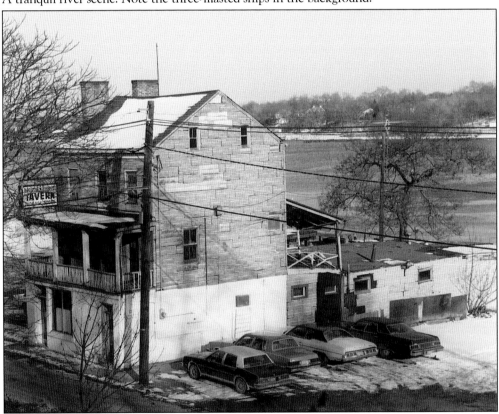

The Harbor Lights Tavern. Many have memories of this riverfront landmark that occupied the Schantz & Eckert site. Destroyed by fire, it is the site of present-day waterfront restoration and is part of the Coastal Heritage Trail.

Two

THE LAND

A convenient town for merchandise,
trade, and fishery

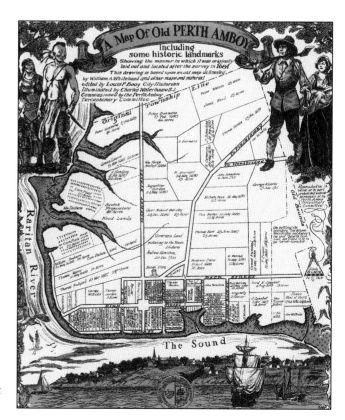

A map showing the early city layout and city seal. Wrote Samuel Groom in 1683: "I have laid out Perth Amboy into 150 lots and have sent home a draught of it." Groom was the first surveyor general and one of the twenty-four East Jersey Proprietors.

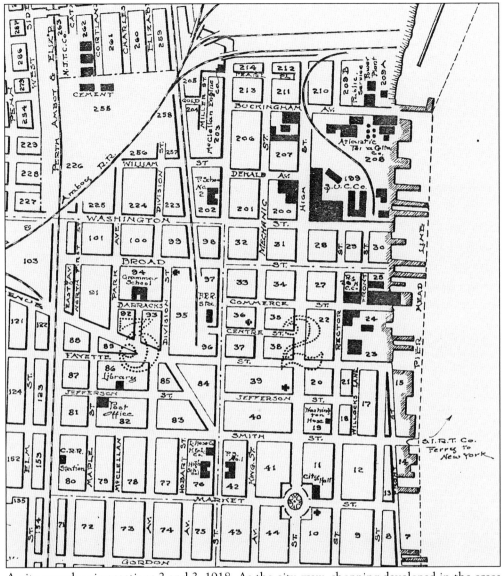

A city map showing sections 2 and 3, 1918. As the city grew, shopping developed in the areas labeled "2" and "3."

The old pump, 1860. Water was supplied from a pump that stood at the center of High Street where it intersected Smith Street (close to the Packer House).

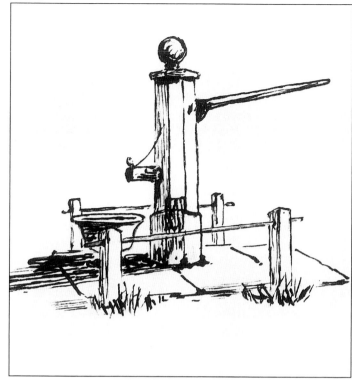

The Pump House at Runyon, c. 1930s. In the photograph are John Toolan and Louis Franke.

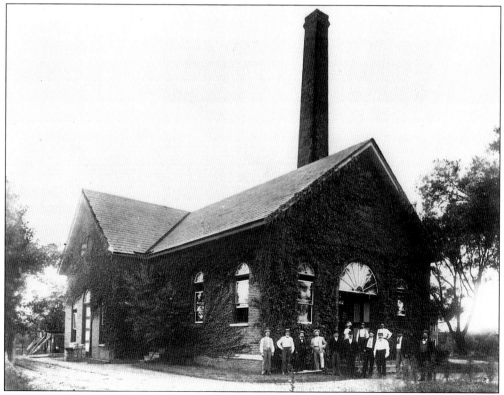

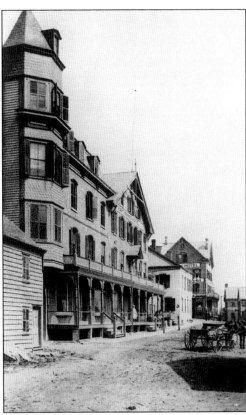

Waterfront hotels. Hartmann's Hotel and the Ferry Hotel were located on Front Street.

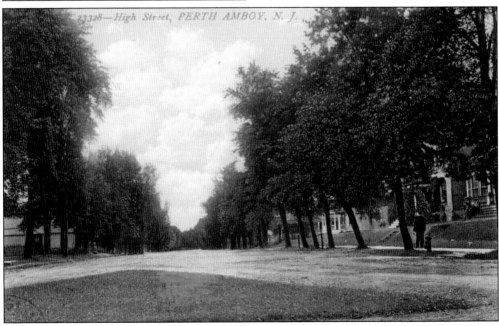

High Street. On Tuesdays and Saturdays in 1820, farmers with their produce and butchers with their meats came to the market in the center of the square on High Street. The town stocks (where drunkards, wifebeaters, and other lawbreakers were punished) were also located here.

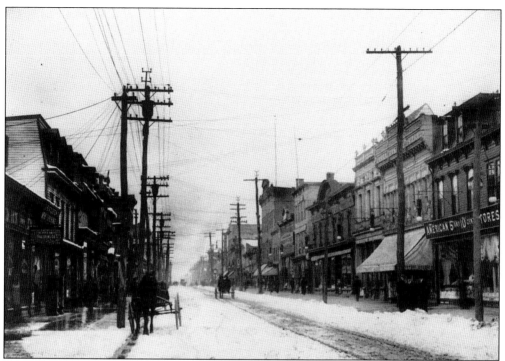

An early Smith Street scene, c. 1800s. The Perth Amboy Tailoring Company, owned by Joseph Shangold and Samuel Fein at 71a Smith Street, is in the left foreground. In the right foreground, the store with the awning is the Boston Store. This shop at 72 Smith Street sold dry goods; Dunbar and McRobie were the proprietors.

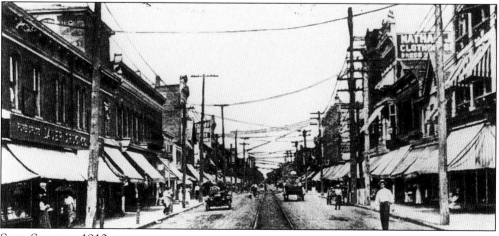

State Street, c. 1910.

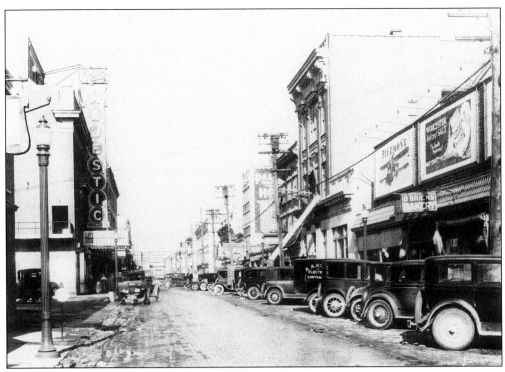

Madison Avenue. Note the Majestic Theatre on the left.

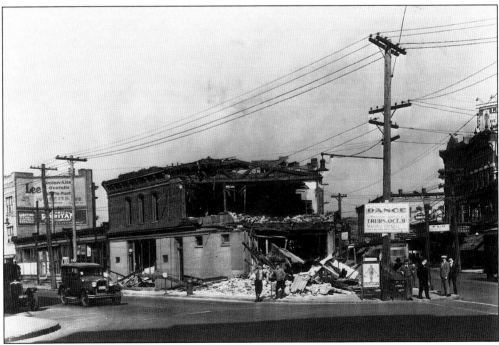

The National Bank. The old building is shown being demolished before the new bank "skyscraper" was built.

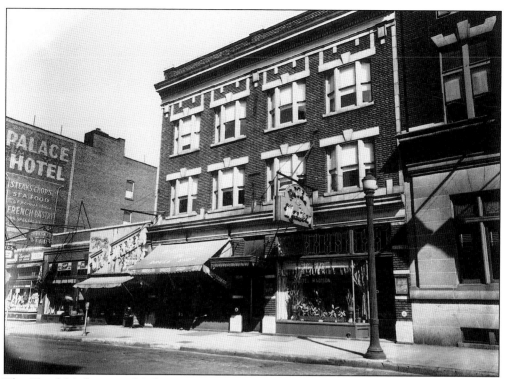

The Hotel Madison on Madison. In 1919, there were twenty-three hotels in Perth Amboy. Actors performing at Proctor's, later to become the Majestic, stayed at the Hotel Madison or the Palace Hotel.

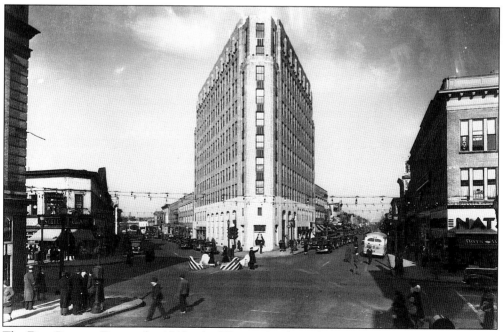

The Five Corners. During the 1940s, the Watson Stock Exchange was on the third floor of the bank building.

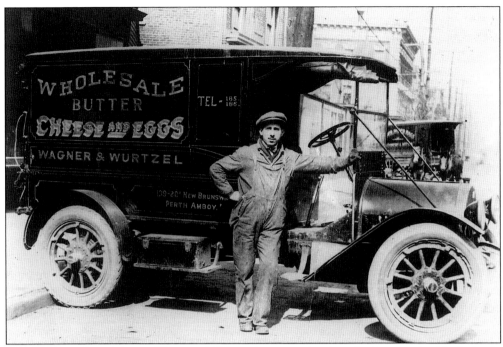

A delivery truck and driver. Wagner & Wurtzel were in the dairy business and sold wholesale butter, cheese, and eggs.

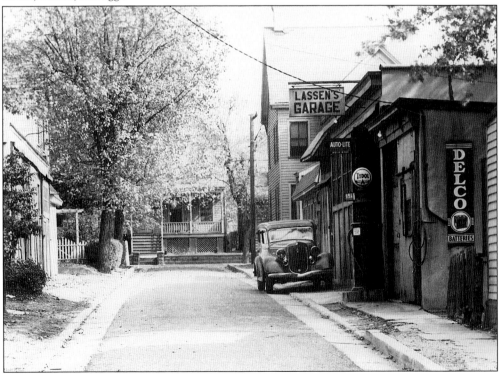

Lassen's Garage. This fine establishment was on Dillon Lane, which everyone called "Gasoline Alley."

A restaurant and hotel, 1919. Empire Quick Lunch, owned by J.P. Kjersgaard, was at 31 Smith Street at the corner of Rector. Located near the ferry, the Kjersgaard's also offered lodging by the day or by the week at reasonable rates.

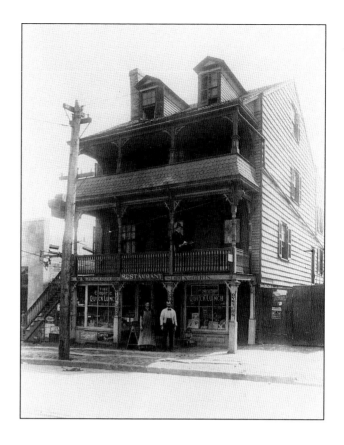

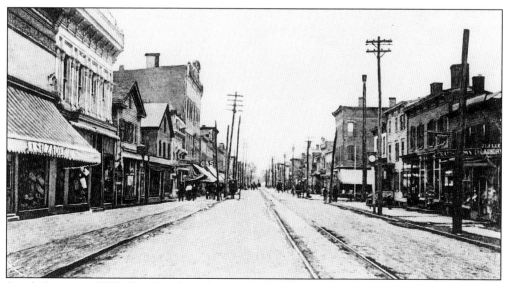

Smith Street, c. 1919. Sam Lee Laundry at 293 Smith Street was one of ten laundries; Pratt-Brown Real Estate was one of eighty real estate agencies.

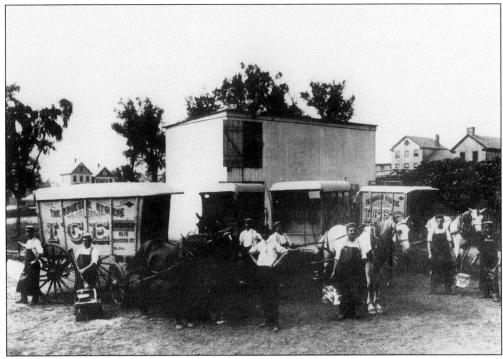

Krueger's Hygiene Ice Company's delivery truck, 15 Division Street. People in Perth Amboy at the turn of the century used ice for refrigeration. There were several ice dealers, including the Dorsey Ice House (with two locations, one on the corner of Gordon and Second Streets and the other on New Brunswick Avenue) and the Perth Amboy Coal & Ice Company (at 501 Division Street).

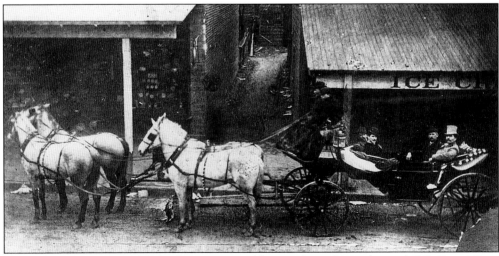

Ice cream, c. 1800s. Could this be Von Spreckle's on State Street beyond Silk Drug? Rose Galvin remembers it as "the best place to buy ice cream."

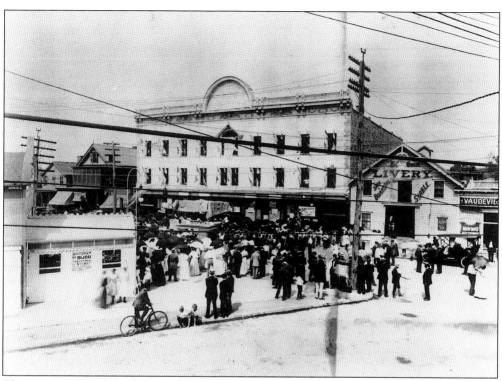

The opening day of the Jefferson Market, 1909. Perth Amboy had many farmers' markets, all of which were located near the railroad. The Jefferson Street Market preceded the library presently on the site.

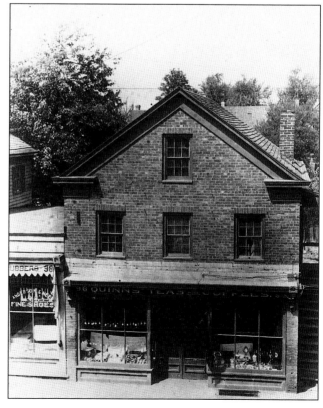

Quinn's Stores. Quinn's sold teas and coffees at 96 Smith Street, a location subsequently occupied by Roth Furniture.

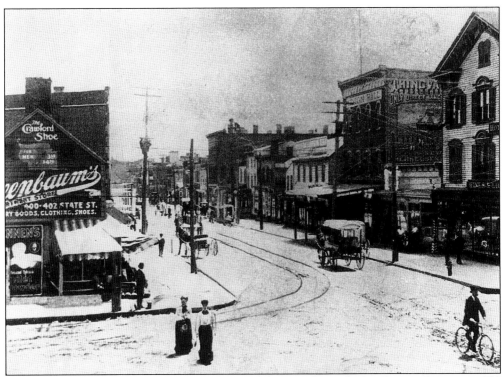

Greenbaum's Department Store, *c.* 1800s. Adolph Greenbaum had a dry goods store at 238 State Street in 1893. This early photograph indicates a 400–402 State Street address.

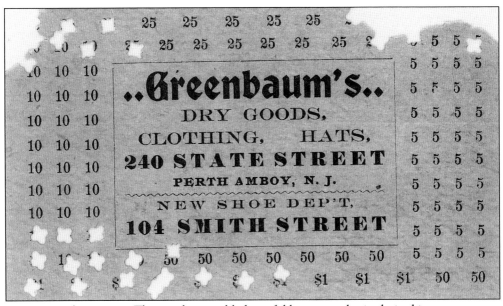

Paying a week at a time. These tickets enabled careful buyers to obtain desired items.

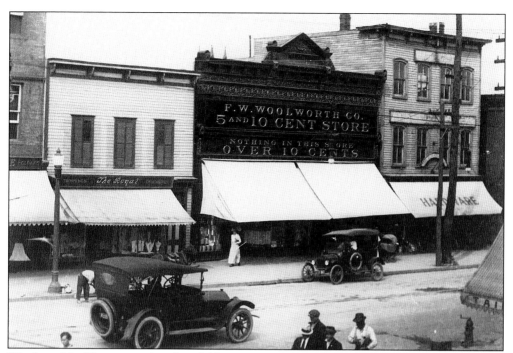

Woolworth's. There were five 5-and-10-cent stores in Perth Amboy in 1919. Wilder Hall, a theatrical space, was a busy place above Woolworth's at 84–86 Smith Street. Later, an elegant Chinese restaurant with dark booths, white tablecloths, and a polished dance floor was located over Woolworth's.

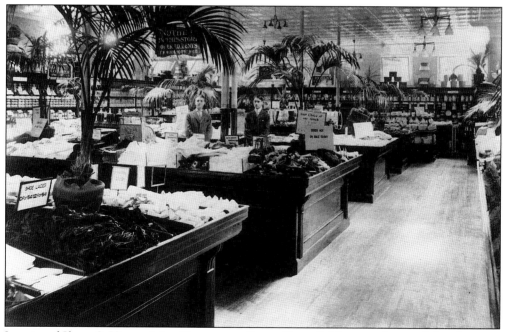

Interior of Sharp & Hanson's Inc Department Store. Sharp & Hanson advertised their business at 158-160 Smith Street. The palms, dapper clerks, oiled wooden floors, and walnut merchandise display tables added a touch of elegance to the low-priced atmosphere.

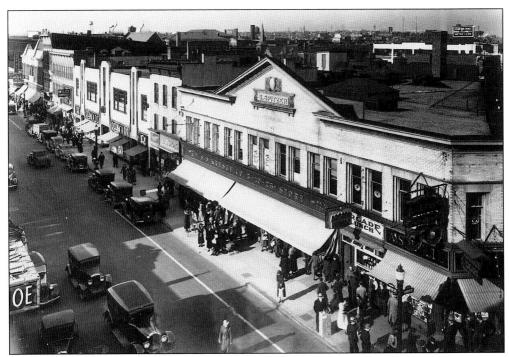

S.S. Kresge's. Many waited for their bus on this very familiar corner. Schulte's sold cigars. Down the street, Reynolds Department Store used pneumatic tubes for handling cash sales. Veronica Smith, in her second-floor office, was able to anticipate transactions as the tubes careened up the walls and ceiling.

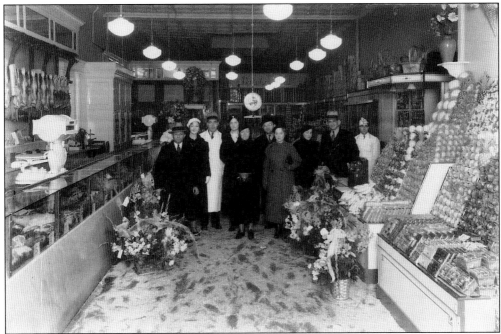

Opening day, Davidson's Market, 1920s. During the Depression, Davidson's on New Brunswick Avenue sold stock to prospective customers in order to finance the opening of the store.

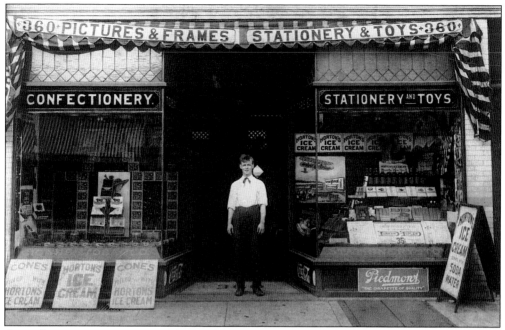

A confectionery, stationery, and toy store, 360 State Street. The first historical mention of Perth Amboy's shopping district concerned "a good stationer's shop of books at New Perth." Benjamin Clarke's Stationer's Shop was referred to as early as 1683 and is presumed to have been in Clarke's home on the south side of Market Street near Water Street.

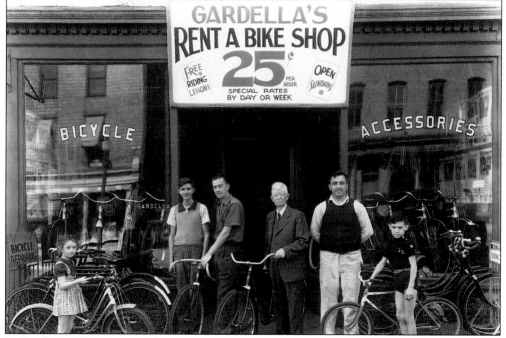

Richard Gardella's Rent A Bike Shop. Gardella's bought, sold, and exchanged bicycles, including the Iver Johnson and the Flying Merkle. The shop sold Fisk, Goodrich, and Pennsylvania Cup Tires.

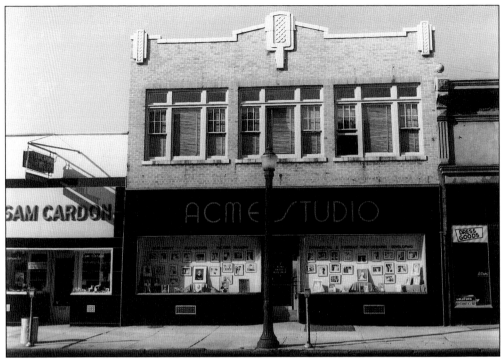

The Acme Studio. The black glass art-deco Acme Studios was owned by Burt Richards for many years. Frank J. Premako bought Acme and has operated it for some time, photographically documenting much of Perth Amboy's industrial, social, and political history.

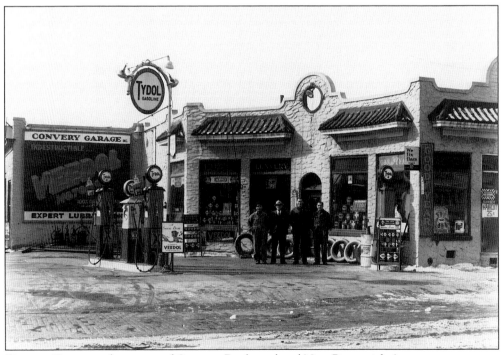

Convery Garage at the corner of Convery Boulevard and New Brunswick Avenue.

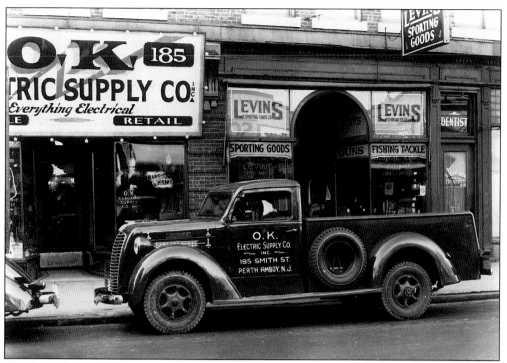

The O.K. Electric Supply Company and Levin's Sporting Goods.

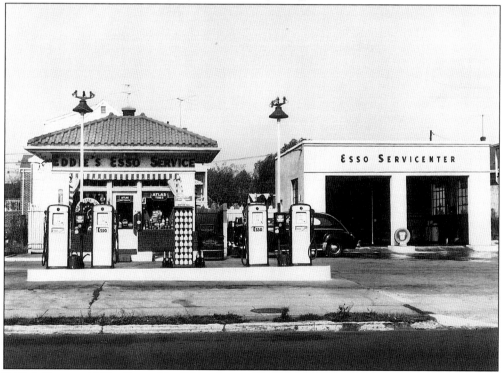

Eddie's Esso, c. 1940s. Owned by Eddie Sespetowski, this neighborhood filling station was the place to fill bicycle tires. It was located at the corner of Silzer and Smith Streets.

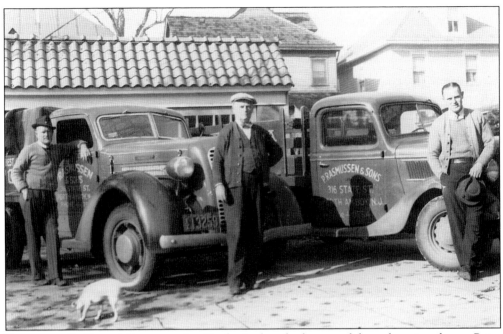

Rasmussen & Sons delivery trucks. Perth Amboy had many fish and oyster shops. Peter Rasmussen & Sons had several locations, including a shop on Smith Street and one on State Street.

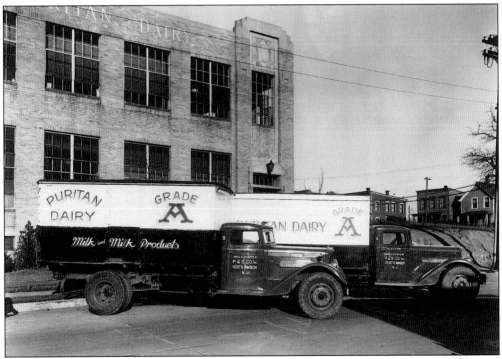

Puritan Dairy delivery trucks. Perth Amboy schoolchildren bought Puritan Dairy Milk in small glass bottles for 4¢. Milk was supplemented by graham crackers or saltines for a mid-morning snack. Keeping the milk money records was part of every classroom teacher's responsibilities.

The Packer House. Since 1692 there has been a hotel on the northeast corner of High and Smith Streets. The Packer House, built in 1760, was the first. Among the other hotels occupying the site were Hicks' Tavern (see p. 70), the City Hotel, and the Phoenix Hotel (also called Drake's Tavern).

The Hotel Packer. The leather-covered Information for Guests booklet at The New Packer House details the hotel's hundred-room, forty-eight-bath European Plan. Rates for transients were "$1.50 per day and upwards, $2.00 per day with bath, and upwards and permanent rates upon application." A tragic fire on March 17, 1969, claimed several lives and burned the hotel.

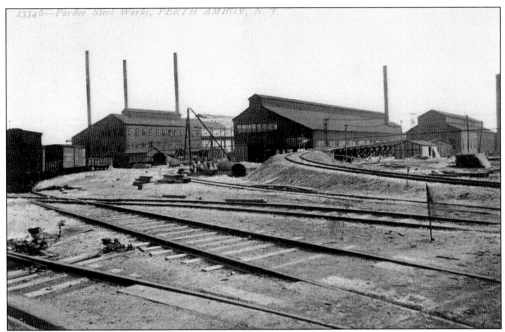

The Pardee Steel Works. At one time the C. Pardee Tile Works was also an iron and steel plant served by the railroad sidings of the Central Railroad.

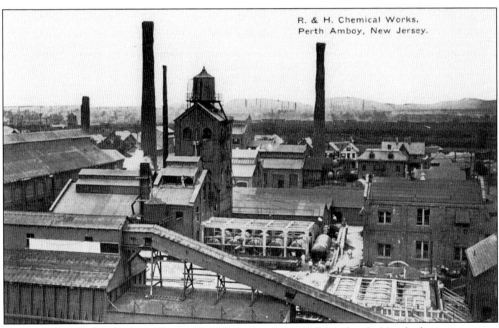

The Roessler & Hasslacher Chemical Company, c. 1910. Roessler & Hasslacher was a very small company when it first came to Perth Amboy in 1889. The company used German methods to manufacture chemicals and subsequently established plants rimming the city at the water's edge. The General Bakelite Company was founded as a result of the production of bakelite from formaldehyde by Roessler & Hasslacher.

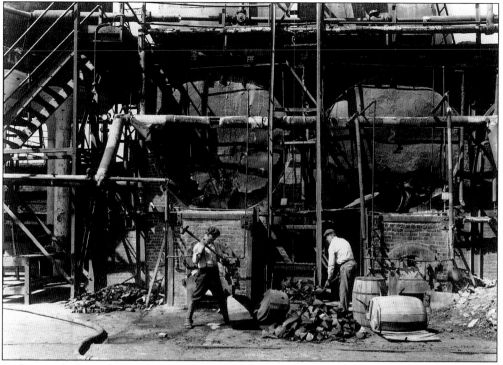

Barber Asphalt workers. The Barber Asphalt Paving Company erected huge refineries and subsidiary plants, refined all the asphalt east of the Mississippi, and turned out thousand of rolls of roofing paper annually.

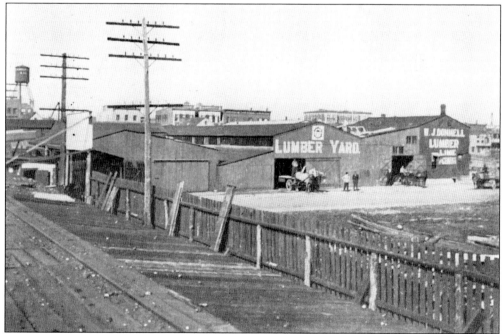

The W.J. Donnell Lumber Company. Located below Philip Carey at the entrance to the Victory Bridge at Smith Street, this company was accessible under the bridge.

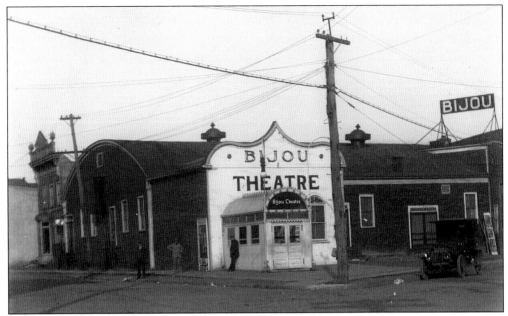

The Bijou, 1909. Feiber and Shea's Bijou Theatre, primarily a vaudeville house, was located at the convergence of New Brunswick Avenue and Jefferson Street. *Gus Edwards' School Kids* with Eddie Cantor, Walter Winchell, and George Jessel appeared there. Seats were 5¢ and 10 ¢. The Bijou burned in 1913.

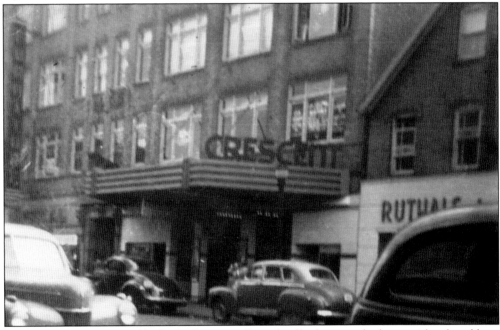

The Crescent, *c.* 1930s. "Chick-chick reviews," vaudeville shows with chorus girls, played here in the 1930s. The Crescent also showed horror movies. Jack Dudas remembers people coming across the stage dressed as monsters and walking down the aisles. Also known as The Royal, the Crescent was restored by Howard Green, president of ABC Theatres, who planned rock and roll shows and envisioned it as a duplex theater.

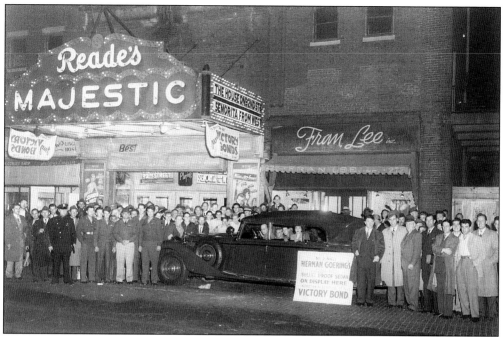

The Majestic, *c.* 1944. Owned by the Walter Reade Organization, the Majestic showed many war movies and was the location for sales of war bonds in the 1940s. On October 26, 1954, the American Ballet Theatre performed here for an enchanted audience.

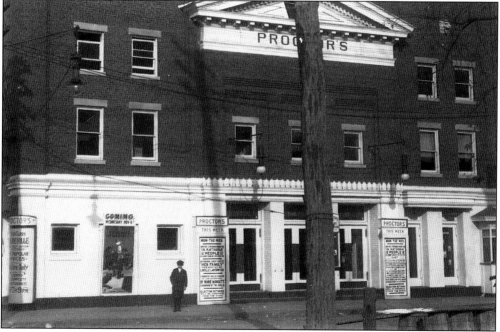

Proctor's, 1908. "She's a wonderful old theater—a beauty in her day," said Charlie White, Perth Amboy's award-winning actor. When owned by Counihan and Shannon, the theater hosted the premiers of conventional productions such as *Abie's Irish Rose.* Once taken over by Proctor's, the theater became a vaudeville house.

The Ditmas Theatre, 1918. The Ditmas on State Street next to School No. 1, adjacent to the building occupied by the *Perth Amboy Evening News*, opened on February 23, 1914. It had an organ and organist for musical accompaniments to silent films. Many local organizations had concerts at the Ditmas.

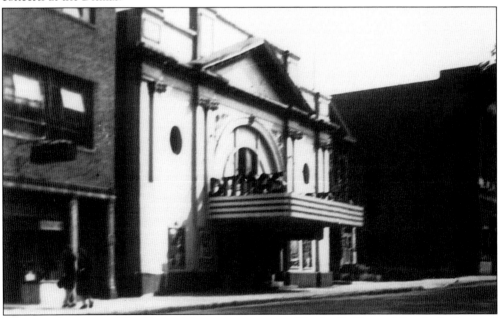

Ditmas in later years. The Ditmas' first operators were Charles R. Rose of South Amboy and Saul J. Barrett of New York. It was "the safest theatre in the state—fire proof and panic-proof." The Ditmas was destroyed by fire on April 1, 1951. It was sold to the Perth Amboy Parking Authority to be used for the State Street parking facilities.

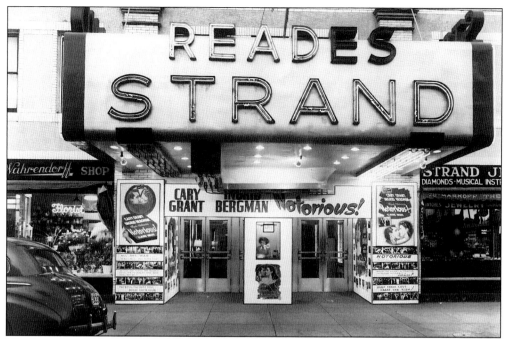

The Strand, c. 1950s. The Strand was originally the George West Furniture Store on lower Smith Street. A 1928 *Perth Amboy Evening News* article reported the following: "Over the weekend experts have been at work in the Strand and Majestic theatres here . . . matinee audiences were greeted at the two popular photoplay theatres by the new sound-synchronized photoplays."

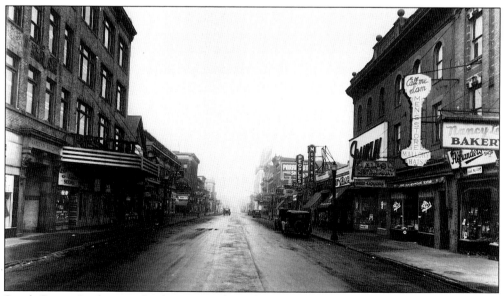

Smith Street. Looking in the distance at the right, one can see Perth Amboy's Grand Theatre, also known as "Garlic House." Renovated in 1928, the theater's name changed to the "Roxy," which was later modified to the "Roky" as a result of litigation by controlling interests of the New York Roxy Theatre. The Roky showed cowboy films, thrillers, and serials such as *The Clutching Hand*.

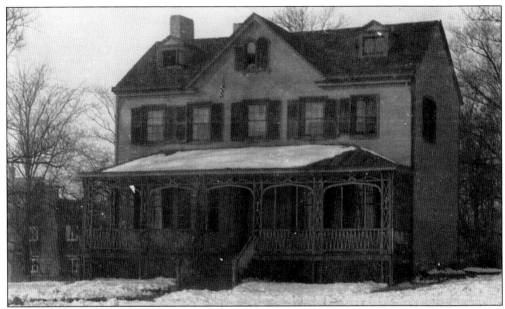

The Truxton House, also known as the Truxton-Levis-Woodruff House. This house was built on Water Street in 1685 by Governor Hamilton and was known as The Governor's House. Commodore Thomas Truxton, who commanded the frigate *Constellation* and defeated the best of the French ships, lived here. Aaron Burr was his guest for a day and a night on July 22, 1804. The house has been torn down.

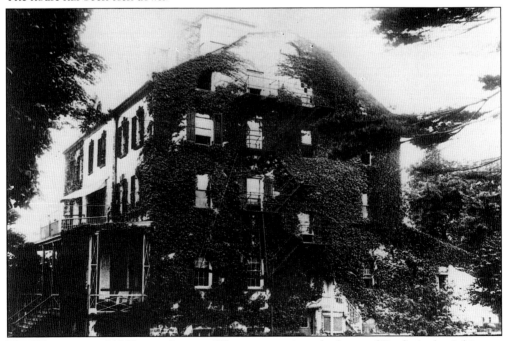

The Westminster, 149 Kearny Avenue. This structure is at the heart of Perth Amboy's history. It was erected to entice the last governor of East Jersey, William Franklin, to live here. Built with bricks brought from England between 1768 and 1770, it was then known as The Governor's Palace.

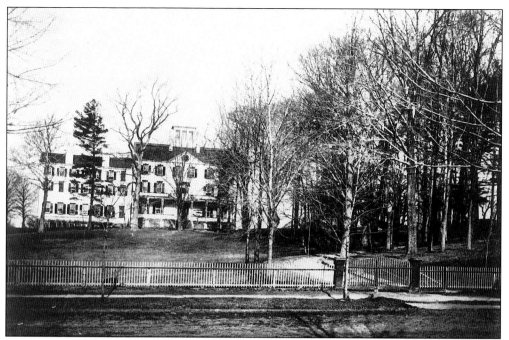

The Brighton Hotel, *c.* 1800s. After the Revolution, the house was neglected. It survived two fires and was bought by John Rattoone. Subsequently, the building was restored, sold, and enlarged, opening as the Brighton Hotel in 1815.

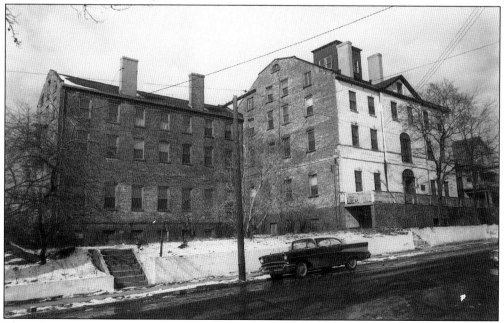

The Proprietary House, *c.* 1950s. In later years, the building was said to be haunted by the ghost of Matthias Bruen, a former owner. Matthias passed the property on to Dr. Alexander M. Bruen, who gave it to the Board of Relief of the Presbyterian Church in 1883. After another series of sales, it became a rooming house. The Proprietary House remains standing in Perth Amboy thanks to the Proprietary House Association, a group of concerned citizens.

Kearny Cottage. Moved from its original site to 63 Catalpa Avenue, the Kearny Cottage was built in 1780 by Michael Kearny. His wife, Elizabeth Lawrence Kearny, was the half-sister of Captain James Lawrence, who lived with them while a boy. Elizabeth and Michael became the parents of Commodore Lawrence Kearny, the second Perth Amboyan to command the frigate *Constellation*.

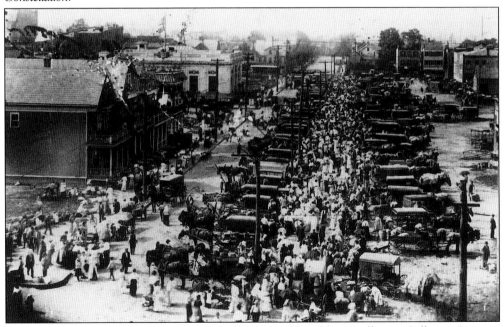

A farmers' market. This market was on Maple Street. The old post office on Jefferson Street is in the background.

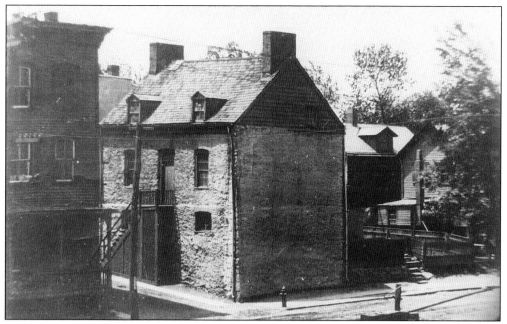

Willocks Lane. This was an area in which the very earliest houses were built by the East Jersey Proprietors to attract settlers such as James Wait, a baker. Wait lived first on the north side and then on the south side of Smith Street at Willocks Lane, which ran from Smith Street north to Fayette Street.

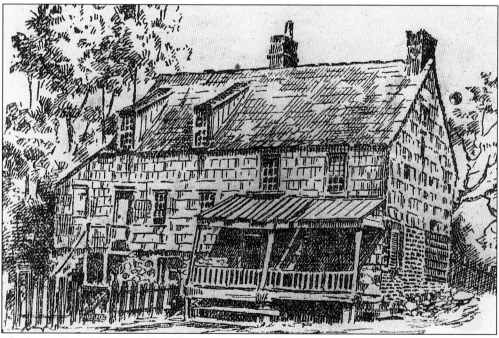

The Long Ferry Tavern, 1684. This area was called "The Love Grove" because of its shady walks. It was named the Long Ferry Tavern because it was near the first ferry across the Raritan River to New York. Mr. Carnes, a giant of a man, was the innkeeper before the Revolution. George Willocks gave the tavern and a tract of land to Saint Peter's Church in 1729.

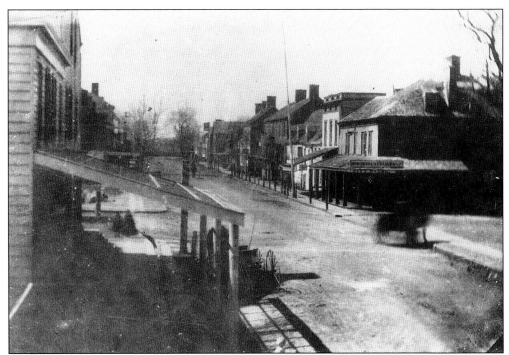

The City Hotel, Hicks Tavern. John Hicks kept a hotel on the corner of Smith and High Streets, the location of the Packer House. Whitehead Hicks had the hotel at the time of the Revolution, and a Tory printer advertised that his newspaper could be purchased at Hicks Tavern.

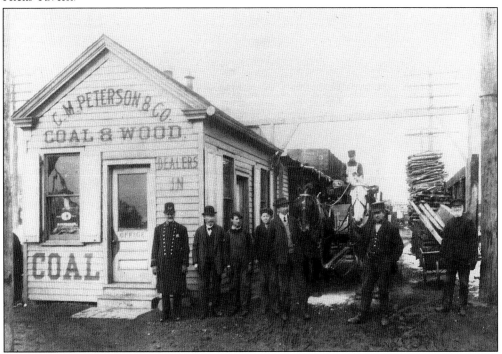

C.M. Peterson & Co., dealers in coal and wood.

Three

THE INSTITUTIONS

Enlarged facilities of every sort

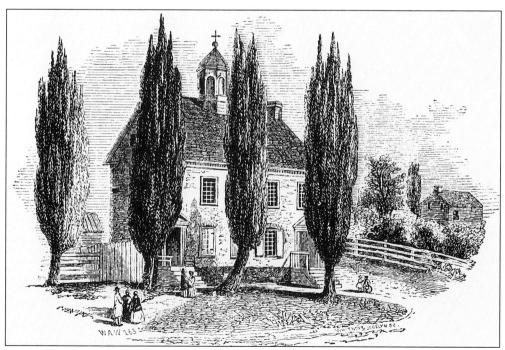

City hall, 1832. The government, churches, schools, library, police, and fire departments of Perth Amboy held it together as a city. The first city hall is thought to have been on Lewis Place, between Gordon and Lewis extending from Water Street to High Street. The Bill of Rights was ratified in New Jersey in Perth Amboy City Hall on November 20, 1789. The present building was occupied in 1925.

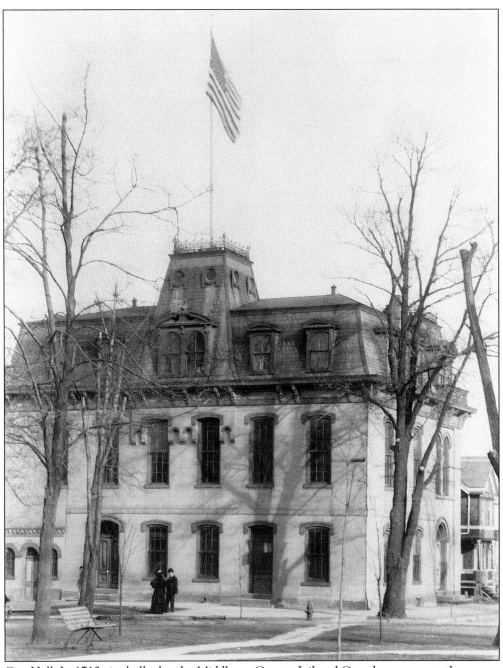

City Hall. In 1713 city hall, also the Middlesex County Jail and Courthouse, was at the corner of High Street and Market. When it was destroyed by fire, a new two-and-one-half-story building was used until 1775. The new building was used as a theater, school, and for a time, for public meetings when the county government moved to New Brunswick. Following this city hall was owned by private interests until it was repurchased by the city in 1858. It was dedicated in 1872.

The East Jersey Club, 1918. James White (left) and George L. Gurmond appear in front of Dr. Kitchell's home, the location of the East Jersey Club. This house was built in 1684 and supposedly was the home of Neil Campbell, one of the royal governors. Dr. Kitchell saved it from being demolished and lived there for many years. John Watson, the first portrait painter in the Colonies, came here from Scotland and lived here until he died in 1715. The King High Garage is there now.

City Hall Park during a dedication ceremony. The park is dotted with reminders of various dedications. Traditionally, it was the location for ceremonies of all kinds. Many events have been memorialized by statues, honor rolls, plaques, trees, and other plantings.

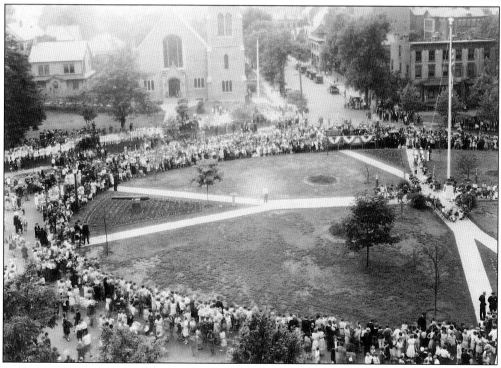

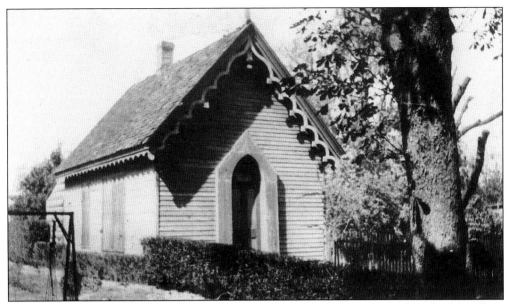

Dr. Charles McKnight Smith's office, *c.* 1880s. Dr. Smith was appointed as health officer because of the cholera fear in 1881. His office was on the site of the parsonage of the First Baptist Church, on High Street in City Hall Park.

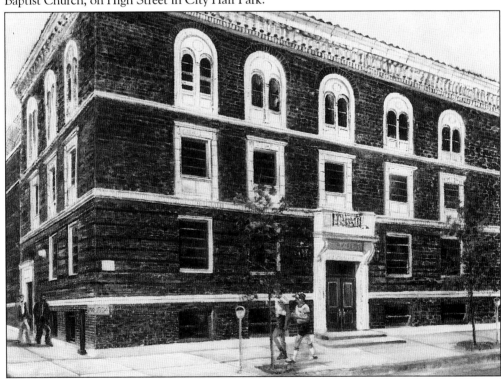

The Young Men's Hebrew Association, *c.* 1920. The first YMHA began as "The Young Men's Club" in 1908 at Washington Hall on Fayette Street. In 1920, Isaac Alpern led a campaign for the construction of this building at the southeast corner of Madison Avenue and Jefferson Street. It was the first YMHA building in New Jersey to be built specifically for YMHA use.

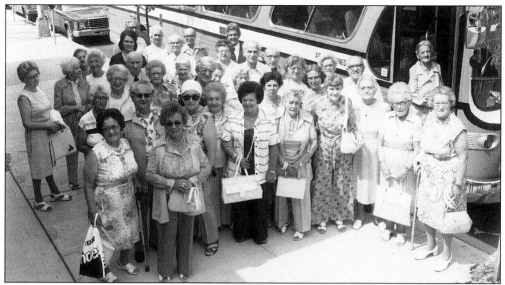

The YMHA Senior Club, c. 1960s. Eloise Rudman, now executive director of the YMHA, and her Senior Club are shown here on one of their popular trips.

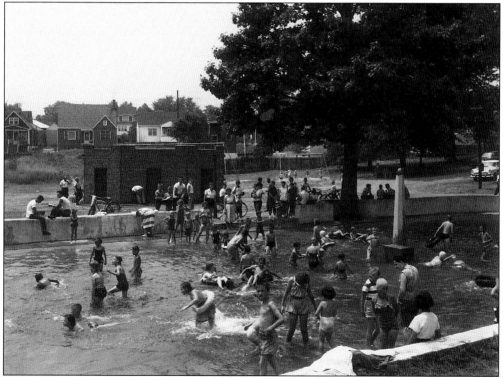

Washington Park, c. 1940s. Another great place to keep cool in Perth Amboy was Washington Park. Water sprayed from a central obelisk into the sloping cement wading pool. Was there a lifeguard?

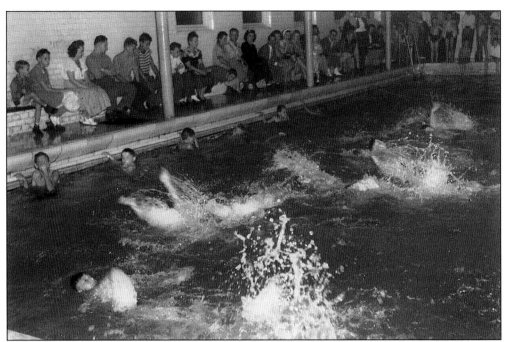

The Young Men's Christian Association swimming pool. The YMCA was built on December 13, 1913. "The call of today is for the enthusiasm and endurance of young men," said Congressman R.P. Hobson at the dedication of the "Y."

A typical YMCA residence. There were fifty-four residence rooms and a lobby, a reading room, and a writing room. The "Y" had a three-story gym with a running track around the upper level, three bowling alleys, a billiard room, a swimming pool, and a lunch counter.

Caledonia Park, 1936. Named for the ship bound for Perth Amboy from Scotland and renown for cherries, shuffleboard, and great old trees, the park was built in the 1930s on the site of the Ashland Emery Mill. It was also the site of the Roessler Gym, now destroyed.

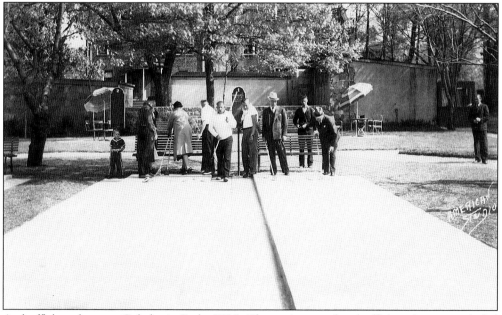

A shuffleboard court, Caledonia Park, 1936. The action on the shuffleboard court included players Morris Dubin, Jack Weitzen, and Albert Waters, after whom Waters Stadium was named.

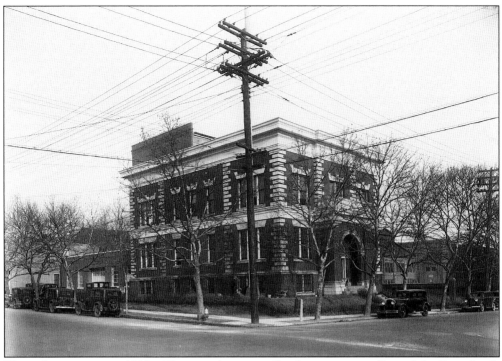

The police station, c. 1930s. This was the originally the corporate office of the Roessler & Hasslacher Company.

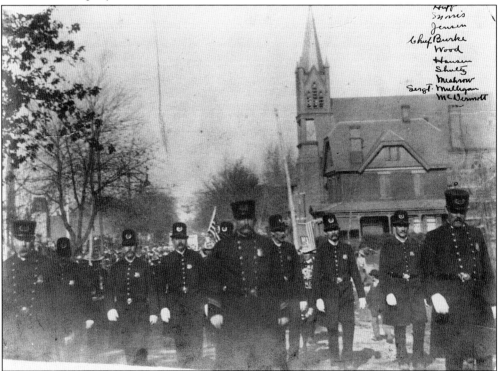

Police on parade, 1901.

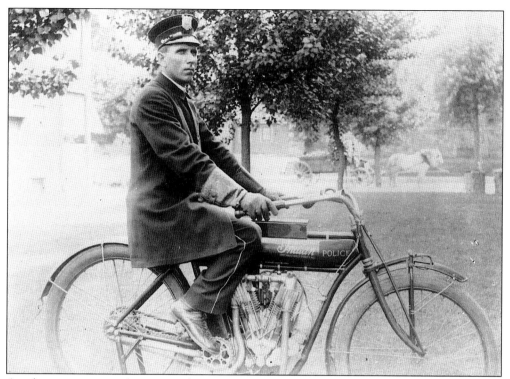

A policeman on an early motorcycle.

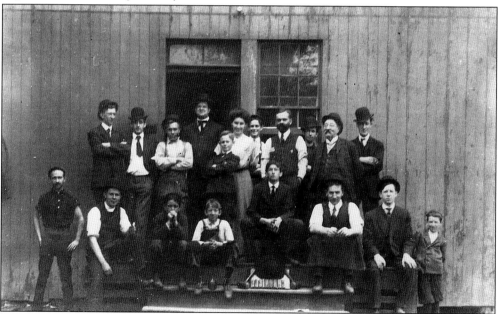

The *Chronicle* newspaper staff, *c.* 1895. A youthful black-bearded Harold E. Pickersgill stands fourth from right in this photograph. Judge Pickersgill purchased *The Perth Amboy Chronicle* from Wilbur LaRoe, its founder. The *Chronicle* was later published by the Perth Amboy Publishing Company. The boards from this building were used to build the airplane hanger at Garretson Field, now the site of Delaney Homes.

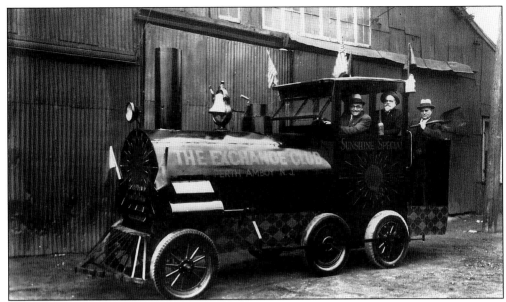

The Peters Iron Works (on the cover). Judge Pickersgill, now white-bearded, sits in the cab of The Sunshine Special. In the background is the Peters Iron Works, which designed and built pole-setting and pole hole-digging machinery. The company also overhauled and repaired automobiles. It was located at 51–53 Fayette Street. Louis P. Booz Jr. was the secretary.

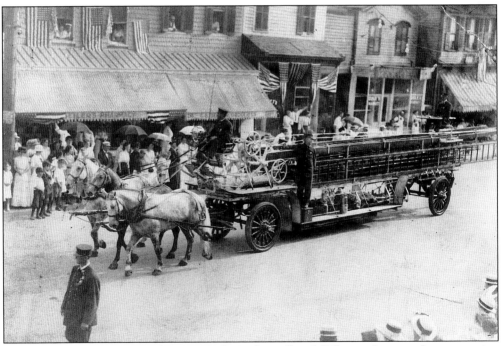

Firemen on parade, lower Smith Street. Judge Pickersgill said, "The city has nine fire companies, which are said to be as efficient as any in the state. The quickness with which they answer the fire alarm, and the promptness with which they reach the scene of action are matters of public knowledge."

Pumpers. Probably this was a Fourth of July celebration. The fire pumpers are turning the corner of High and Smith at the old Packer House.

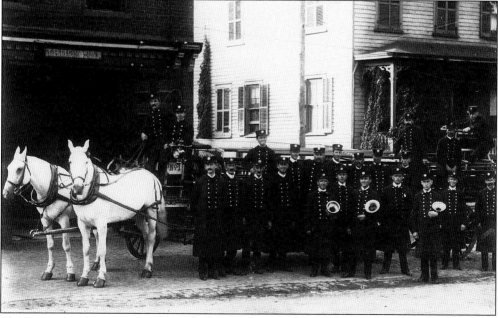

The Protection Company Band. Perth Amboy's fire companies were Lincoln Hose; Washington Hose; McClellan Engine, No. 3; Eagle Hose, No. 4; Garfield Engine, No. 5; Liberty Hook and Ladder, No. 2; and Humane Hook and Ladder Chemical. This and the following two photographs chronicle the development of the Protection Firehouse.

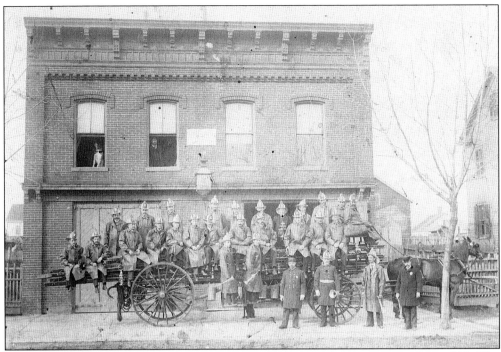

Protection Hook and Ladder, *c.* 1885. Engine No. 1 was organized in January 1882. The Protection Firehouse was on State Street next to what now is the McGinnis School.

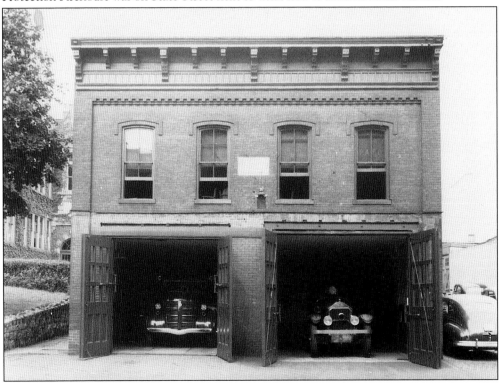

No more horse-drawn fire engines, *c.* 1930s.

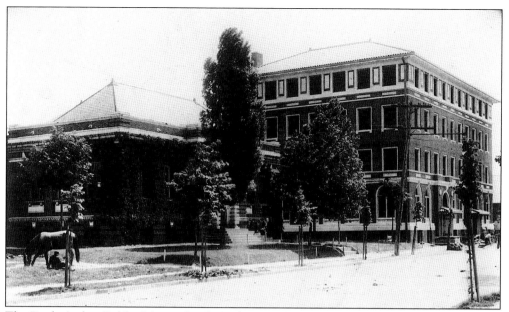

The Perth Amboy Public Library. Perth Amboy's early settlers were well educated. Books were important to them. Thomas Jefferson wrote that New Jersey's farmers were the only farmers he knew who could read books in the original Greek. A group of public-spirited women headed by Miss Annie Rea Bower agitated for the founding of the library in 1888.

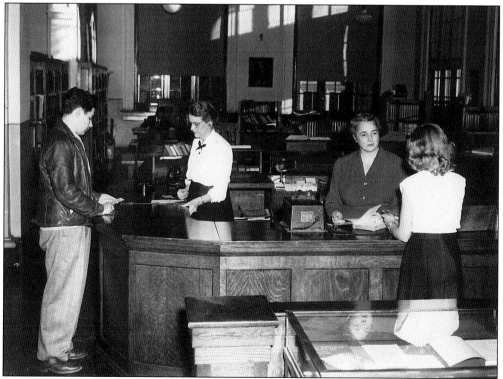

The circulation desk. Miss Anna Cladek (on the right), director of the library, encouraged reading with popular summer reading programs for children. The library was a city institution.

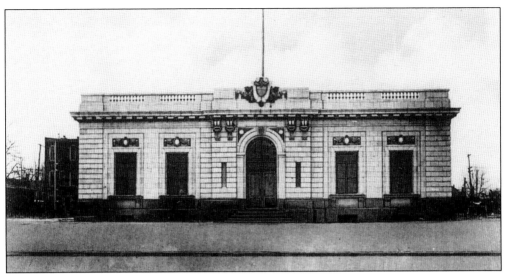

The Federal Building, April 2, 1906. The post office had many locations. This is the "new" Federal Building, which was located on the site of the present building. The site was sold to the government for $1 by the Middlesex Realty Company; Isaac Alpern, then in the real estate business, still has the check. The building was made of local terra cotta, most of it white with blue trim over the windows. George H. Tice was then postmaster, and the first customer was Miss Bessie Abildgaard. The building was later demolished for a newer "new" post office.

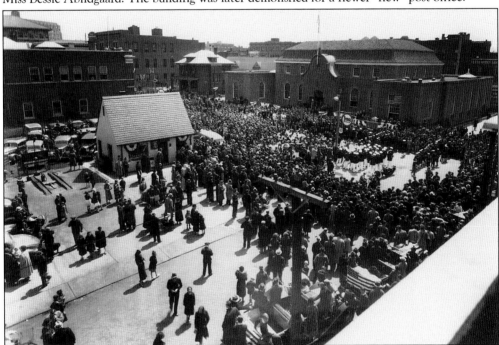

The "new" Post Office dedication, April 14, 1937. The new post office, a Spanish Colonial with a dull brown exterior and terra-cotta trim of the same color, was to have an entrance on Maple Street. It didn't. The Women's Club started a movement to develop artwork depicting historical events in the city. Service clubs such as the Lions and the Exchange Club joined in supporting this.

The temporary Post Office, 1935. The white terra-cotta federal building was closed on November 30, 1935. Temporary quarters were leased at 224B Smith Street through the real estate agency of Jacobson and Goldfarb.

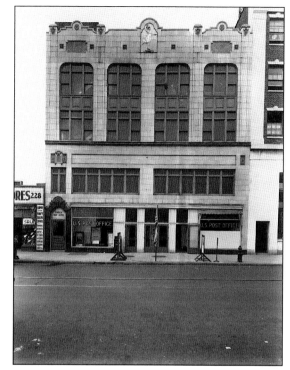

Dignitaries at the new Post Office dedication, April 14, 1937. Mayor Edward Patten is third from the left in the first row.

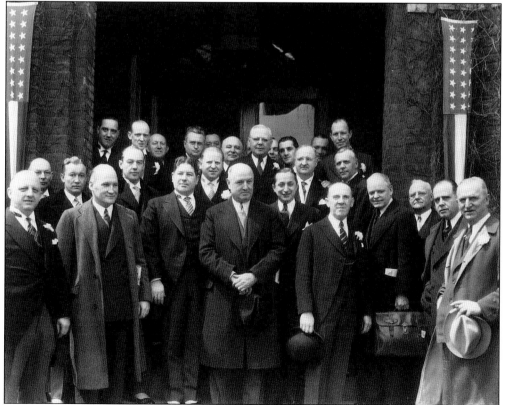

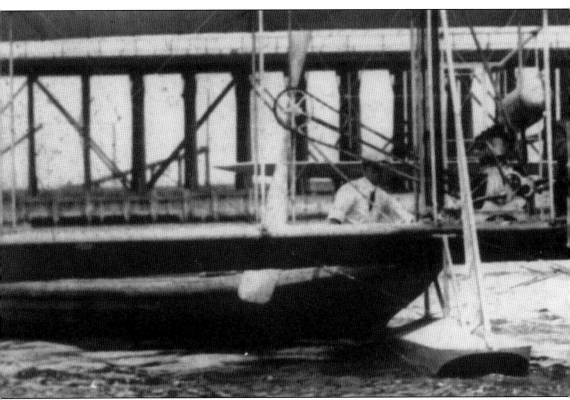

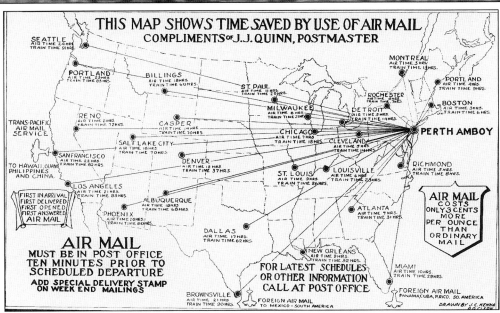

THIS MAP SHOWS TIME SAVED BY USE OF AIR MAIL
COMPLIMENTS OF J.J. QUINN, POSTMASTER

SEATTLE
AIR TIME 24 HRS.
TRAIN TIME 91 HRS.

PORTLAND
AIR TIME 23 HRS.
TRAIN TIME 72 HRS.

BILLINGS
AIR TIME 18 HRS.
TRAIN TIME 60 HRS.

ST. PAUL
AIR TIME 11 HRS.
TRAIN TIME 10 HRS.

MONTREAL
AIR TIME 5 HRS.
TRAIN TIME 13 HRS.

PORTLAND
AIR TIME 4 HRS.
TRAIN TIME 9 HRS.

RENO
AIR TIME 21 HRS.
TRAIN TIME 72 HRS.

MILWAUKEE
AIR TIME 6 HRS.
TRAIN TIME 21 HRS.

ROCHESTER
AIR TIME 4 HRS.
TRAIN TIME 14 HRS.

DETROIT
AIR TIME 5 HRS.
TRAIN TIME 14 HRS.

BOSTON
AIR TIME 3 HRS.
TRAIN TIME 6 HRS.

TRANS-PACIFIC
AIR MAIL
SERVICE

CASPER
AIR TIME 14 HRS.
TRAIN TIME 70 HRS.

CHICAGO
AIR TIME 7 HRS.
TRAIN TIME 18 HRS.

CLEVELAND
AIR TIME 5 HRS.
TRAIN TIME 19 HRS.

PERTH AMBOY

SAN FRANCISCO
AIR TIME 22 HRS.
TRAIN TIME 82 HRS.

SALT LAKE CITY
AIR TIME 18 HRS.
TRAIN TIME 70 HRS.

DENVER
AIR TIME 13 HRS.
TRAIN TIME 37 HRS.

RICHMOND
AIR TIME 5 HRS.
TRAIN TIME 8 HRS.

TO HAWAII, GUAM
PHILIPPINES
AND CHINA.

ST. LOUIS
AIR TIME 9 HRS.
TRAIN TIME 26 HRS.

LOUISVILLE
AIR TIME 6 HRS.
TRAIN TIME 23 HRS.

FIRST IN ARRIVAL
FIRST DELIVERED
FIRST OPENED
FIRST ANSWERED
AIR MAIL

LOS ANGELES
AIR TIME 21 HRS.
TRAIN TIME 83 HRS.

ALBUQUERQUE
AIR TIME 18 HRS.
TRAIN TIME 68 HRS.

PHOENIX
AIR TIME 20 HRS.
TRAIN TIME 80 HRS.

ATLANTA
AIR TIME 7 HRS.
TRAIN TIME 31 HRS.

AIR MAIL
COSTS ONLY 3 CENTS MORE PER OUNCE THAN ORDINARY MAIL

DALLAS
AIR TIME 17 HRS.
TRAIN TIME 62 HRS.

AIR MAIL
MUST BE IN POST OFFICE TEN MINUTES PRIOR TO SCHEDULED DEPARTURE
ADD SPECIAL DELIVERY STAMP ON WEEK END MAILINGS

NEW ORLEANS
AIR TIME 9 HRS.
TRAIN TIME 32 HRS.

MIAMI
AIR TIME 10 HRS.
TRAIN TIME 29 HRS.

FOR LATEST SCHEDULES OR OTHER INFORMATION CALL AT POST OFFICE

BROWNSVILLE
AIR TIME 21 HRS.
TRAIN TIME 90 HRS.

FOREIGN AIR MAIL
TO MEXICO - SOUTH AMERICA

FOREIGN AIR MAIL
PANAMA, CUBA, P.RICO, SO. AMERICA

DRAWN BY J.C. KENNA
S.O. CLERK

A map showing air mail times. This map, which made Perth Amboy look like the nerve center of the postal system, is well conceived. Perth Amboy's postal history is impressive. What was perhaps the first post office was on the site of Andrew Hamilton's home, on the westerly side of High Street, south of Market. Hamilton was postmaster general for the Colonies and John Hamilton, his son, continued in the same post.

The first air mail delivery, July 4, 1912. The first air mail delivery in the world was made from South Amboy to Perth Amboy with a hydroplane flown by O.G. Simmonds, who was accompanied by Mayor Ferd Garretson. Mayor Garretson sat on two wooden crosspieces, held onto the struts with both hands, and placed the leather mailbag on his lap. The plane landed at Bayard's Beach, where Mayor Garretson delivered the mail to Postmaster William H. Pfeiffer.

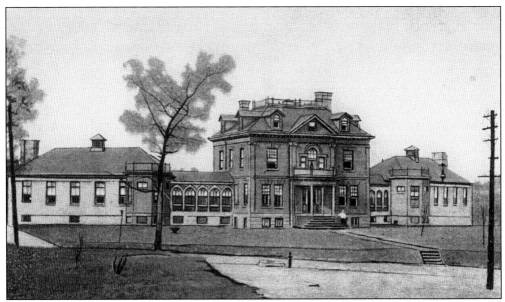

Perth Amboy Hospital, 1901. The Perth Amboy City Hospital Association was organized in the 1880s and raised funds for building a hospital. The cornerstone for the building was laid on Memorial Day, 1901. The hospital had thirty-seven beds and looked like a small school. Cows and horses grazed on the grassy banks. The first operation was performed on June 23, 1902—an appendectomy.

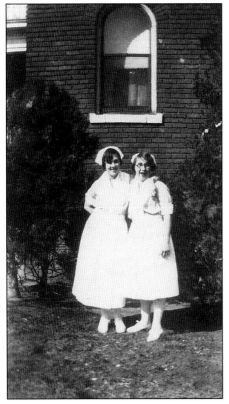

Graduation day, 1932. Ruth Larson Orr (left) and Beatrice Schulmeister met while training at Perth Amboy Hospital's nursing school and became friends.

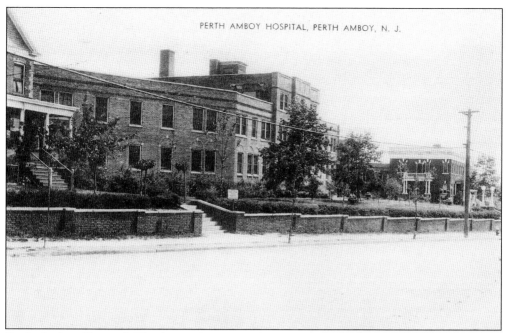

PERTH AMBOY HOSPITAL, PERTH AMBOY, N. J.

Perth Amboy Hospital. The hospital continued to grow as a modern institution; its doctors specialized in urology, obstetrics, gynecology, pediatrics, orthopedics, and many other fields.

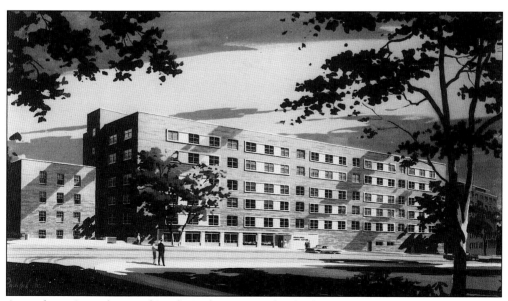

An architect's rendering of Perth Amboy Hospital. The hospital ranked as one of the better institutions in New Jersey. A building expansion program increased operating room space and added more beds.

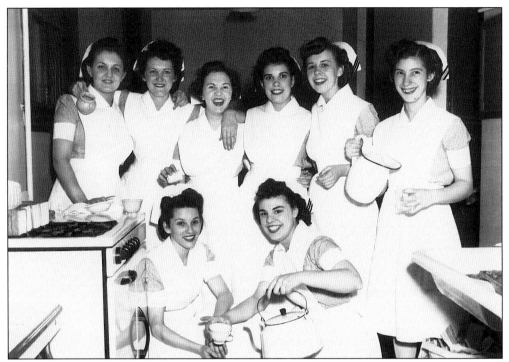

Perth Amboy Hospital student nurses.

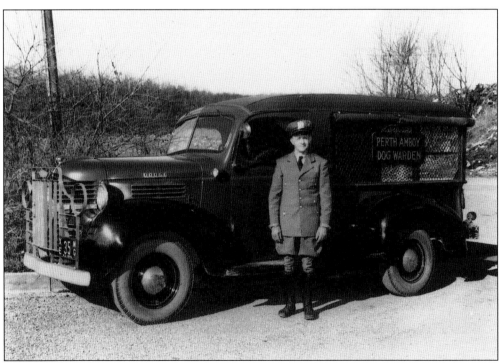

Mr. Moore, the Perth Amboy dog warden.

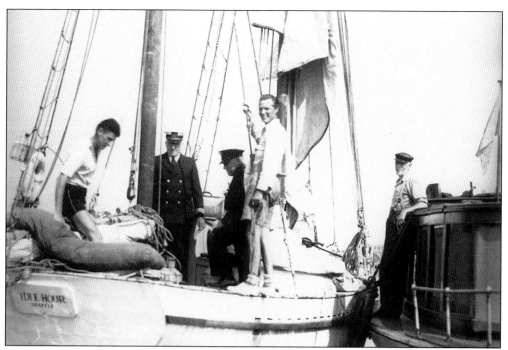

Inspecting a vessel for possible contamination, *c.* 1940s. Harbor Inspector Dr. Charles W. Naulty (facing center in uniform) was in charge of the quarantine station in Perth Amboy between 1907 and 1945.

A gentleman and his automobile.

A postcard message, 1911. A new wing was added to the south of the high school to accommodate the ever-growing number of students and their needs for science and commercial courses. Also in 1911, a domestic science department was added in the basement to teach cooking and sewing.

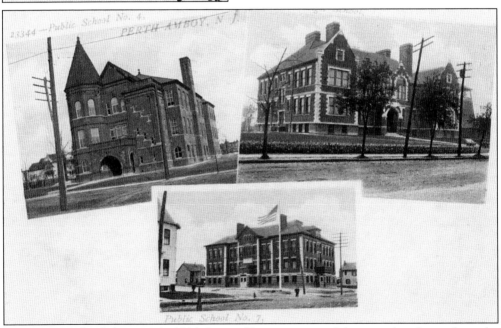

A composite school photograph, 1911. Janitor Hansen requested that steps be taken to keep the cows and geese of the neighborhood off the finely kept lawn of the new school, which opened in 1896. A resident's letter to a local newspaper questioned, "Why were schools numbered? Shouldn't the new No. 7 school on Patterson Street be named the "Patterson School?" After being included in School No. 1, the high school was finally given its own place in 1900.

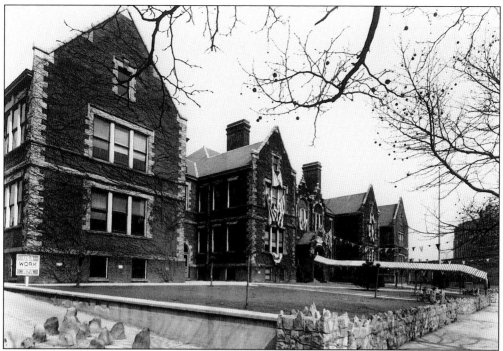

Perth Amboy High School, *c*. 1930s. Still growing and exceeding its 1,200-student capacity—with an enrollment of 1,533—the high school got an addition. A gymnasium, manual training department, and art department were added. The gymnasium was divided into two sections: one for boys and one for girls. Miss Alice Bjork and Miss Arnita Kozusko taught sports to girls and Mr. Stanley Rosen and Mr. Ralph Stauffer taught the boys.

Saint Mary's High School. Saint Mary's built the second school in Perth Amboy twenty years before the first public school (Saint Peter's was the first in 1765). The high school was built in 1922 and graduated eight boys and seven girls in its first class in June 1926. A gymnasium was built in 1940; Saint Mary's teams competed against Catholic and public high schools in basketball, track, and baseball.

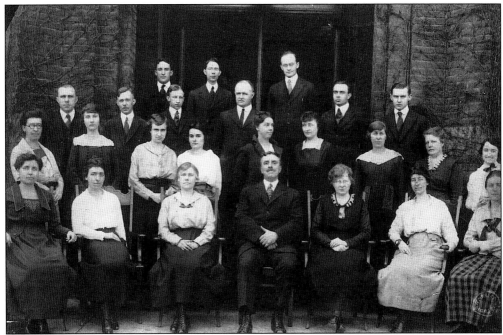

The High School faculty, c. 1924–28. The quality of education in Perth Amboy's schools rivaled and exceeded that of private schools. Will Ramsay (second row, fourth from the left) was principal of the High School from 1924 to 1940. Following Will Ramsay, Rose McCormick (front row, third from the left) was appointed principal; some feared that "no woman could fill the shoes of Mr. Ramsay," but Miss McCormick served with distinction from 1940 to 1945.

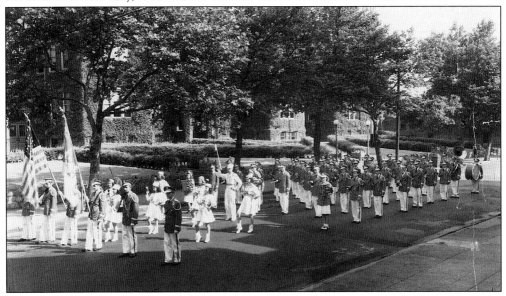

The Perth Amboy High School Band, c. 1950s. Its uniforms were derived from the school colors—red jackets and crisp white trousers for the male members and red skirts and white shirts for the girls. The band was part of school life. They practiced every morning at 7:30 before school in order to march in parades and during half time festivities at football games, where they made giant "P" and "A" formations.

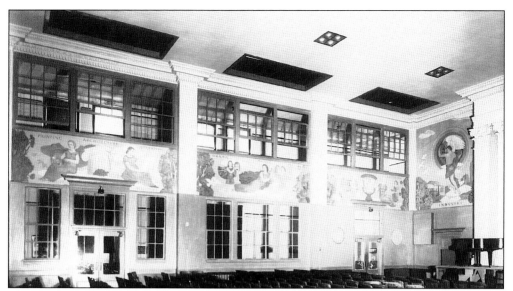

The Perth Amboy High School (McGinnis School) auditorium murals, 1935–38. The side panel murals on the south wall show figures representing Painting, Architecture, Literature, and Sculpture. The north side panels have three murals, each depicting one of nine disciplines: Astronomy, Research, Radio, Chemistry, Electricity, Aeronautics, Philosophy, Geography, and Physics. The murals were painted by artist Karl Lilla and have recently been restored.

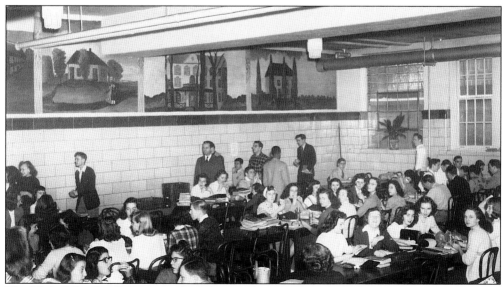

The High School cafeteria mural, 1953. Lunch was a time to dump your books on the long tables, head for the back of the line, and decide what to have. One favorite was melted cheese on toast with bacon, and another, swordfish. Friends sat together, checking out who was with whom, worrying about tests, and gossiping with friends. Adele Lakomski managed the cash register, monitored the food line, and tolerated no nonsense from anyone.

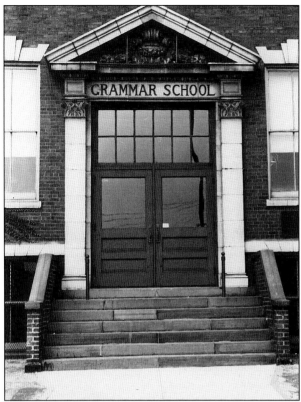

The Grammar School entrance. Before the Grammar School, the British Barracks were here, hence the street name: Barracks Street. When the barracks were torn down in 1909, the Grammer School was built. It was the largest school in Perth Amboy at the time. Mr. Edward J. Seaman, the principal, was legendary. He personally reviewed all student report cards. He had a strict code for behavior and dress. Boys had to wear neckties. He paid careful attention to both with a disciplinary policy that got results.

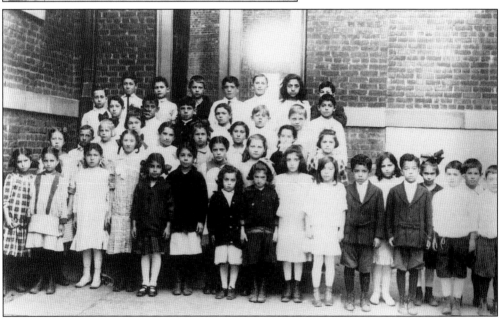

School No. 1, first grade, 1914. Classes were identified by the letters A, B, C, D, E, and F, with A being the highest level. Sixth from the left in front of Perth Amboy's first public school is Florence L. Seguine, and next to her, seventh from left, is Rose Turtletaub. Friendships made at School No. 1 lasted a lifetime.

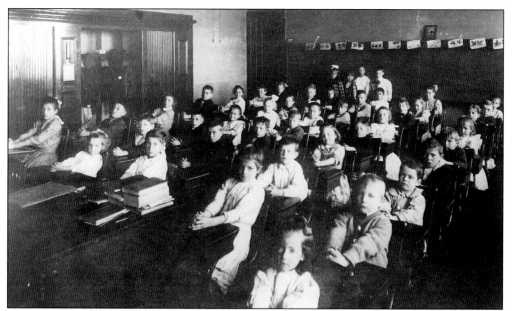

An early school room. A classroom register was used to keep track of attendance and often contained general comments, such as these from School No. 2: "One session, stormy-wind N by E; rooms very noisy, men carrying in radiators; general election (Republicans vastly in the majority); superintendent was here the entire afternoon."

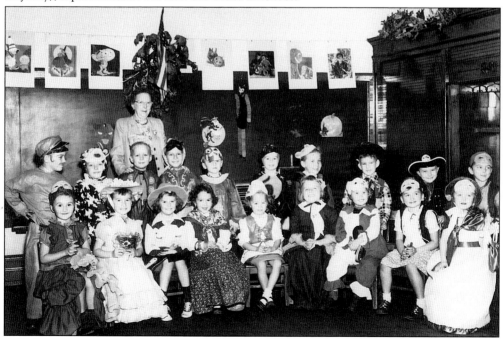

A Halloween party at School No. 10, 1951. In 1915, when this school was built, sixty-five children went to a morning session taught by one teacher and ninety others went in the afternoon. Two teachers taught afternoons, one facing the front and one facing the back. Miss Mary Fitzgerald is shown here with her sub-primary class at their Halloween party. Marilyn Dudash is in the first row, second from the left.

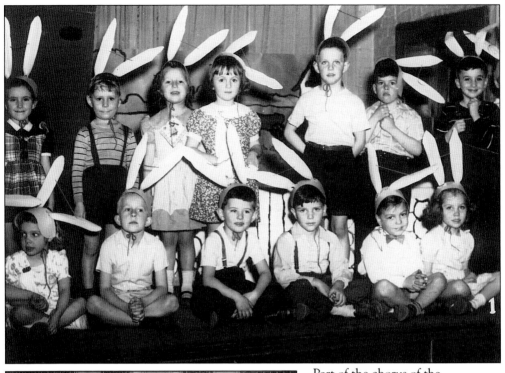

Part of the chorus of the operetta *Peter Rabbit*, School No. 8. All children in Miss E. Mullin's sub-primary and Mrs. Rosengarten's kindergarten classes participated in this production. The background and scenery were painted by the sub-primary children. The headdresses worn by the chorus were made by the kindergarten children.

The Samuel E. Shull School entrance. Originally the No. 11 School, on May 5, 1932, this institution was dedicated at the recommendation of Dr. McGinnis in honor of his predecessor as superintendent of schools. The school was intended not only to serve its immediate neighborhood, but also to relieve overcrowding in Schools No. 5, 6, 8, and 9 in 1926–27.

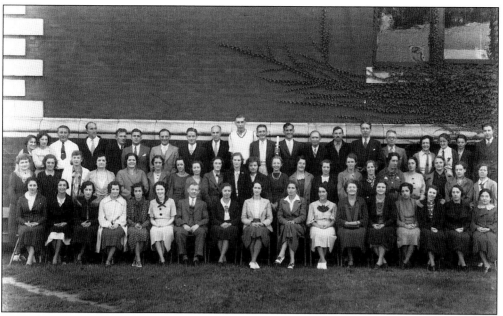

A Perth Amboy High School class reunion.

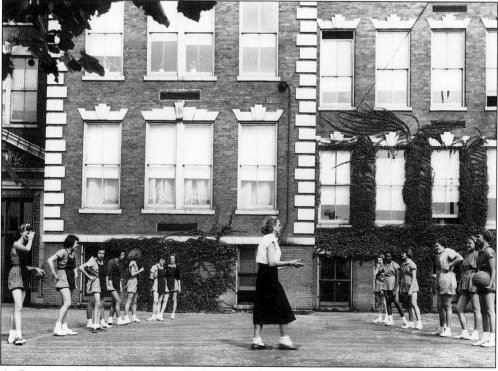

A Grammar School girls' physical education class. Virginia Koehler encouraged her girls' classes to play volleyball and baseball in fine weather. In weather not so fine, the program moved indoors to a basement room. Green uniforms were required—the school colors were green and white—and student's names names had to be stitched at a precise distance above the pocket.

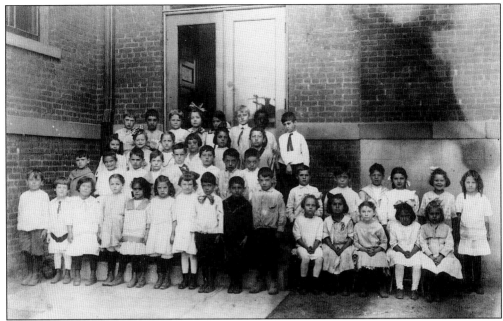

School No. 1, 1912–13. It seems as if everyone went to School No. 1 (now the Thomas Mundy Peterson School), if not as students, then as beginning teachers. Some, like Rose Galvin (the girl with the bow in the back row), dedicated their lives to education and stayed part of the Perth Amboy school system for a long time. Rose Galvin was principal and a school with her name honors her contributions today.

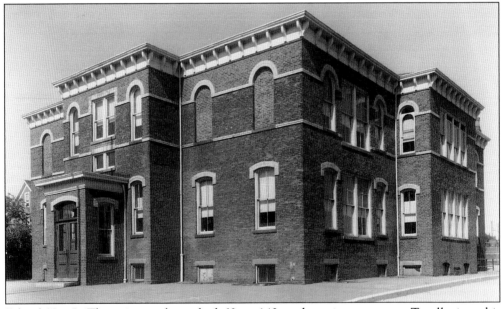

School No. 2. The primary classes had 60 to 140 students in one room. To alleviate this overcrowding, an addition had to built. Unfortunately, the plans did not include specifications for bathrooms. The council voted $725 to correct this oversight, causing rage and indignation. A newspaper reported, "we can proudly boast of having the most costly and convenient outdoor toilet facilities in the State of New Jersey."

Saint Stephen's, c. 1940s. The Polish community grew from the first few settlers in 1880 to a large group with a desire to have a resident Polish priest and a chapel. They first worshiped in a rented store in Schiller's Building on New Brunswick Avenue, and later moved to a wooden church and school building. This stone Gothic church with its impressive spire was built in 1915.

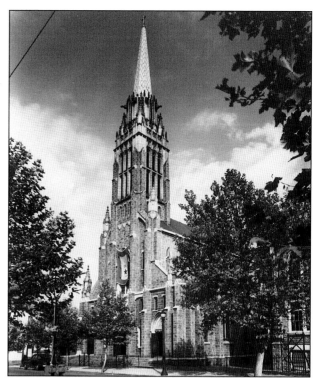

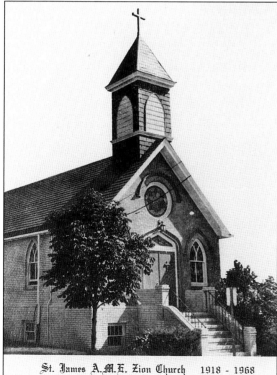

St. James A.M.E. Zion Church 1918 - 1968

68 Commerce Street Perth Amboy, New Jersey

The Saint James AME Zion Church, 1925. The first African-American Methodist church in Perth Amboy— the "City of Churches"—was begun in a storefront building in 1918. Reverend Davis remembers that Perth Amboy had 85 churches—and 165 saloons. It is impossible to show all the churches in this book; a representative selection is included. It is even more impossible to show all the saloons.

101

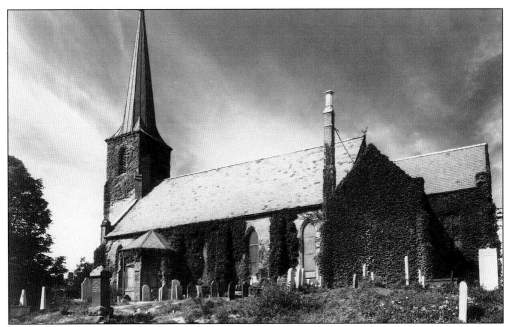

Saint Peter's Episcopal Church and graveyard. The oldest church in Perth Amboy and the oldest Episcopalian church in the country, Saint Peter's was built on land known as the Long Ferry property. A stone taken from the first church is marked "1685." The second St. Peter's Church was begun in 1719 and dedicated in 1722. The present church was built in 1852. The graveyard bears the marks of cannon balls fired during the Revolution and the gravestones include those of William Dunlap, the nation's first theatrical designer, and John Watson, the nation's first portrait painter.

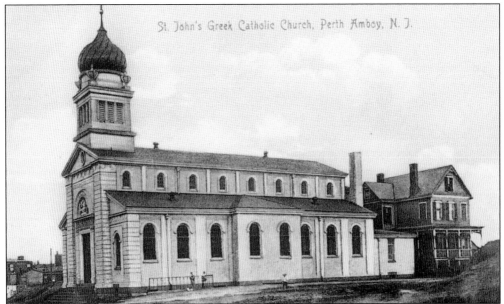

Saint John's Greek Catholic Church. "A Heaven on Earth" is how the Greek Orthodox describe their churches. The Perth Amboy sanctuary is shaped like a ship, forging a theological connection and also a geographical one, since the church's site is on the waterfront.

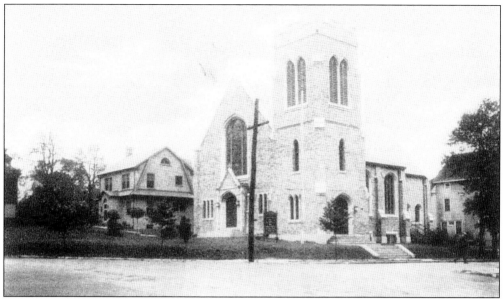

The First Baptist. The first Baptist minister, Drake Wilson, baptized twelve people in the Raritan River. He was very convincing, and new members were converted to the Baptist faith. The original location of the church was on the northwest corner of Fayette and High Streets. In the midst of a building campaign for a new church, World War I began and stopped the plans. The congregation met for a while in the YMCA, and in a portable church.

Beth Mordecai. The first synagogue was built on Hobart Street in 1897 and was called "the German shul." The congregation was named for president Henry Wolff's deceased son. In 1927, a new building was erected on land owned by Saint Peter's Church. Max D. Davidson became the rabbi in 1928.

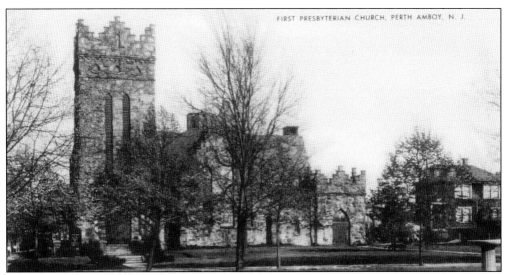

The First Presbyterian Church, 1903. Strong winds blew the *Henry and Francis*, a ship transporting Scottish refugees, into Raritan Bay. David Simpson, the ship's chaplain, was the first Presbyterian minister to hold religious services in Perth Amboy. The other early leaders of the church were born in Scotland. This is the second oldest church in Perth Amboy; its cornerstone was laid in 1802.

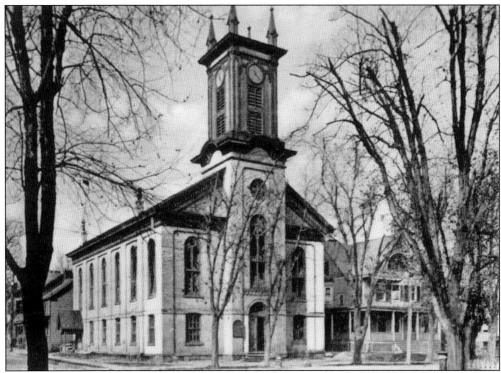

The Simpson Methodist Episcopal Church, *c.* 1869. Methodists held services in Perth Amboy as early as 1772, meeting in private homes and the courthouse before the church was built in 1866. The town clock is in this church because of an agreement made with the city. The board of aldermen bought the clock for $700 and it was installed in the church tower.

Four

THE PEOPLE

You can take the people out of Perth Amboy, but . . .

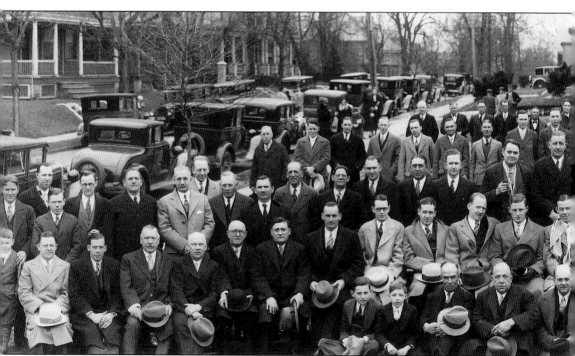

The Everyman's Bible Class, 1932. Judge Adrian Lyon organized the Everyman's Bible Class, which was open to all men in the city. It met Sunday mornings in the sanctuary of the First Presbyterian Church. The group was enormous. The judge, close to the center of this photograph (which extends over the next three pages), was a respected, powerful, and popular personality.

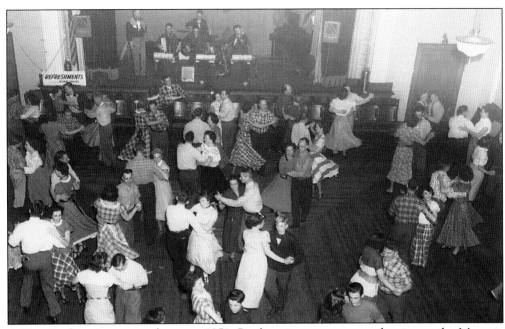

A First Presbyterian square dance, *c.* 1951. Presbyterians were square dancing at the Masonic Temple on the night the Barge Restaurant burned at its moorings in the Raritan River.

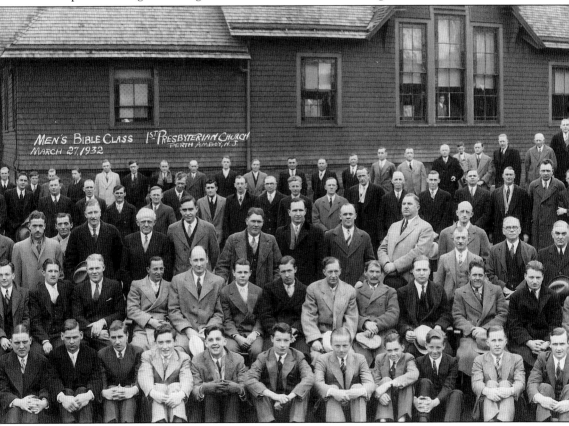

MEN'S BIBLE CLASS 1ST PRESBYTERIAN CHURCH
MARCH 27, 1932 PERTH AMBOY, N.J.

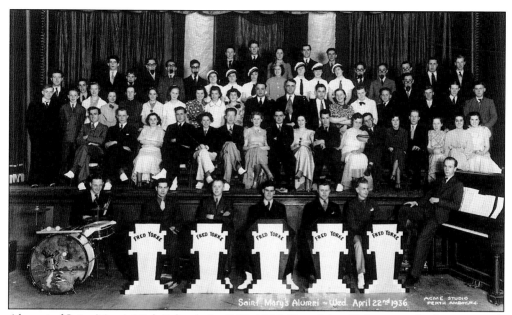

Alumni of Saint Mary's High School, April 22, 1936. Sister Mary Helena was the first principal. The original faculty consisted of Sister Mary Hildegarde, Sister Mary DeChantal, Sister Mary William, Sister Mary Grata, Sister Mary Grace, and Sister Mary Leonard.

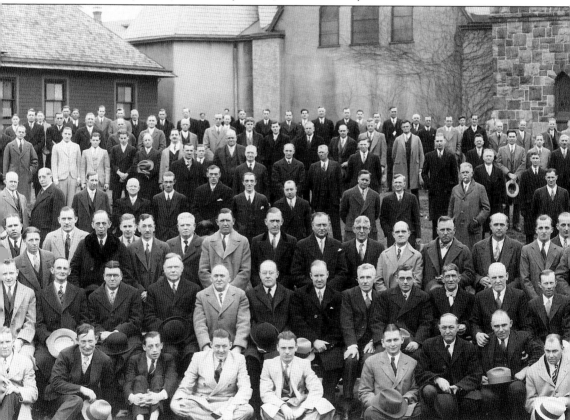

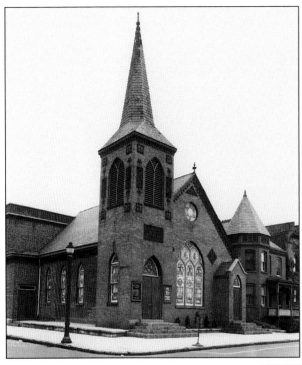

"The People's Church." The Grace Evangelical Lutheran Church and manse were built on the corner of Jefferson and Madison Avenues in 1903. In 1958 the church relocated to 600 New Brunswick Avenue. Since that time, it has been a home for congregations of the Jewish faith and presently houses the Advent Baptist Church.

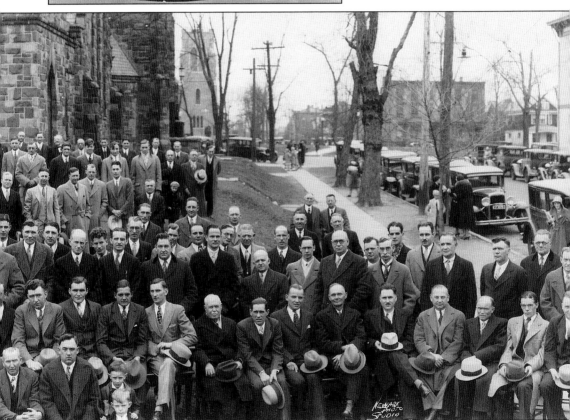

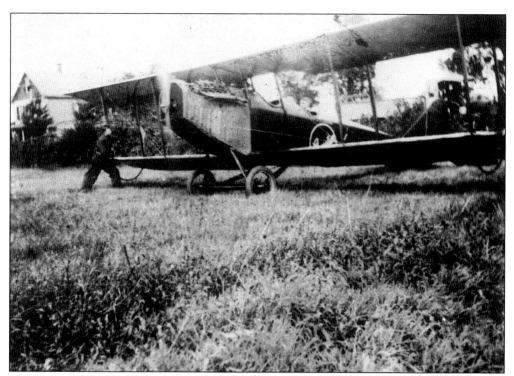

Garretson Field, Perth Amboy's first airport, located where the Witco Company plant is now. This was where many residents had their first airplane ride. The airport was built with the wooden planks from the *Perth Amboy Chronicle* building.

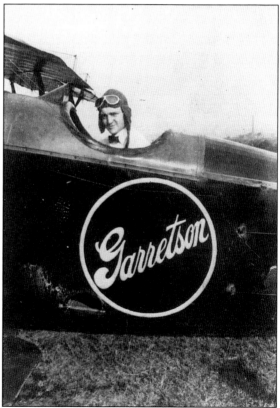

William Garretson in the cockpit of his plane, 1919. William Garretson was the first person in Perth Amboy to learn how to fly an airplane. His career was illustrious, his accomplishments too numerous to list. He graduated from Lafayette College and the Princeton University School of Military Aeronautics. He served in both World War I and World War II and was actively involved in flying and teaching flying; he retired as a colonel in the United States Air Force in 1955.

Ann Dillman. On the right is the president of Perth Amboy's Board of Education, Ann Dillman, who subsequently became president of the New Jersey Board of Education. Next to her is Perth Amboy Board of Education member Gilbert Augustine.

Dr. Harold E. Pickersgill. The history of Perth Amboy would be diminished without the contributions of Harold E. Pickersgill. He worked for the Lehigh Valley Railroad and was a printer, journalist, publisher of *The Mosquito* newspaper, judge, and keeper of the city seal.

Dr. William C. McGinnis. Dr. McGinnis was superintendent of schools from 1930 to 1953.

The Perth Amboy Tennis Club.

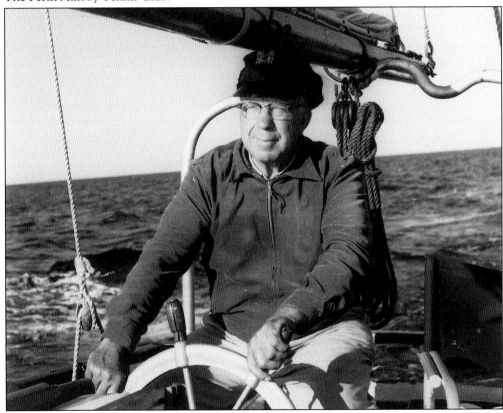

Louis P. Booz Jr. on his boat, the *Maid of Perth*, 1952. Mr. Booz was Perth Amboy's civil engineer and was a man with a list of accomplishments. Mr. Booz was a Rutgers athlete, a nationally known conservation expert, and a consulting engineer. His wife was Mae Rasmussen. The Ramussen family owned a fish store on State Street. Booz's son, Louis P. Booz III, is a graduate of Rutgers and also a civil engineer.

POPULAR SCIENCE
MONTHLY

· FOUNDED 1872 ·

January 1932 Vol. 120, No. 1

RAYMOND J. BROWN, *Editor*

SIXTIETH YEAR

He *Flew* an AIRSHIP

Before the Wrights Were Born!

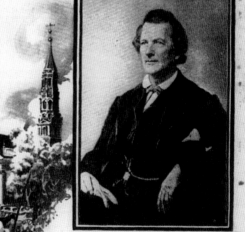

THE year was 1863; the month, June. The Civil War was at its height. Men in stovepipe hats and wearing sideburns and women in poke bonnets and crinolines weighed the chances of McClellan and Lee. The railroad, in America, was only thirty-five years old; telegraphy, scarcely twenty. Stagecoaches lumbered over dirt roads; sidewheelers churned noisily along the Mississippi. Flying lay still in the realm of dreams; the Wright brothers were not yet born.

Yet in that year an American inventor and patriot designed, built, and successfully piloted a dirigible! By a queer twist of fate, history does not record the marvelous feat of this pioneer. You will seek his name in vain in the annals of aviation. But he and his amazing accomplishment live in dusty official documents, yellowed newspapers, and long-forgotten letters in public and private files.

By
Roger B. Whitman

An exhaustive investigation and examination of this mass of material recently completed for POPULAR SCIENCE MONTHLY enables me to tell the thrilling story of the world's first practical airship and the courageous genius who was its builder and pilot. The strangely neglected hero of this saga, whose name should occupy a place of honor beside those of Stephenson and Fulton, is Solomon Andrews.

Andrews was the first man to

Drawing of the flight of Andrews' airship over New York City in 1866. The craft was designed for use by Northern forces during the Civil War

Drawing by B. G. SEIELSTAD

DR. SOLOMON ANDREWS

*S*TARTLING FACTS Found in Old Records, and Set Forth for You in This Article, Prove Unknown American Built and Piloted a Dirigible More Than Sixty Years Ago

A *Popular Science* article about Dr. Solomon Andrews, January 1932. Although few people know this, Perth Amboy was home to both an inventor and an Inventors Institute. Using the British Barracks, Dr. Solomon Andrews, mayor of Perth Amboy and constructor of its outstanding sewer system, built a device called an "Aereon" (meaning "age of air") and flew it on June 6, 1866. It was elliptical and was described as a "Flying Fish." His Aerial Navigation Company's motto was "Without Eccentricity There Is No Progression."

Burlfine's Confectionery, c. 1950. Candy kitchens were favorite gathering places. The Eagle Candy Kitchen (owned by Peter Mezinis) and the Amboy Candy Kitchen were both on Smith Street. Burlfine's was on State Street. Mr. Burlfine is shown here behind the counter. Thomas Gustenhoven (at the far end of the counter), owner of The House of Yuen, is one of his customers.

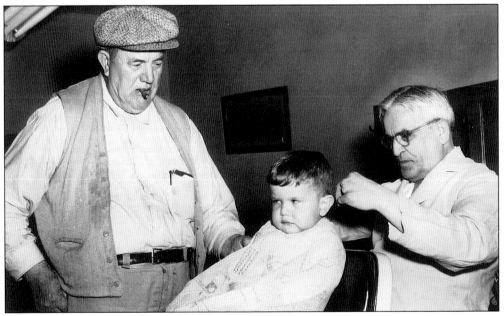

A first haircut, c. 1956. As a result of political turmoil in Hungary, groups of displaced persons found shelter in Perth Amboy and New Brunswick. The kindness of Perth Amboy's community shines from the eyes of one benefactor as he sees to a little boy's haircut by Mr. Marcy, a barber whose shop was on Smith Street.

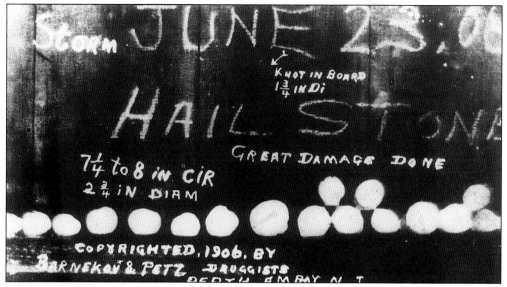

The hailstorm of June 1906. From out of the blue came a hailstorm with pellets like cannonballs, powerful enough to break windows. Charles W. Barnekov and Henry H. Petz, druggists at 335 State Street, recorded the meteorological event.

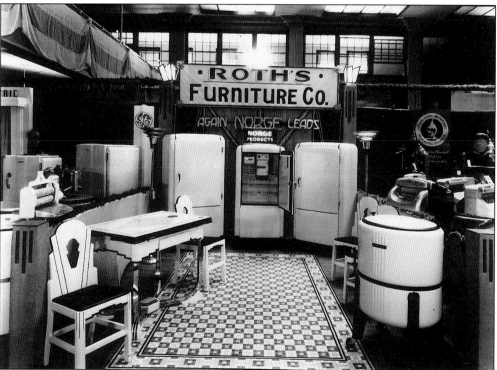

The Roth's Furniture Company exhibit, 1936. The Home Show was a display of wares from Perth Amboy's businesses and institutions held at the Perth Amboy High School. Here, Roth's offers the appliances and kitchen furniture of the day. Other exhibitors were Philip Schlesigner (an office supply store), Lepper Furniture, and Boynton Brothers Insurance. The public library had an inviting display of comfortable chairs, a reading light, and a bookcase full of books.

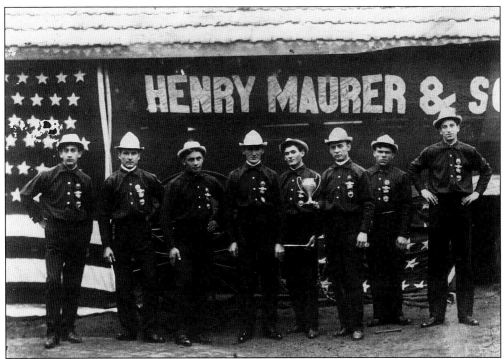

A Maurer and Sons team. The industries sponsored company baseball teams and activities of all kinds.

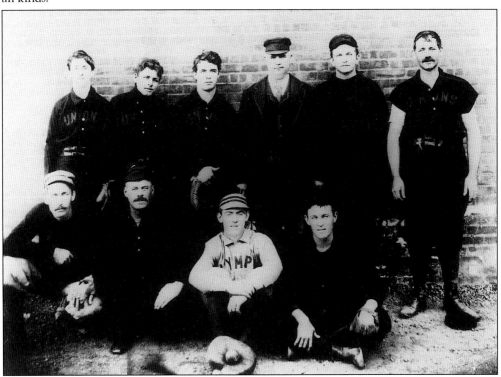

A Union baseball team. Rose Galvin's father is third from the left in the top row.

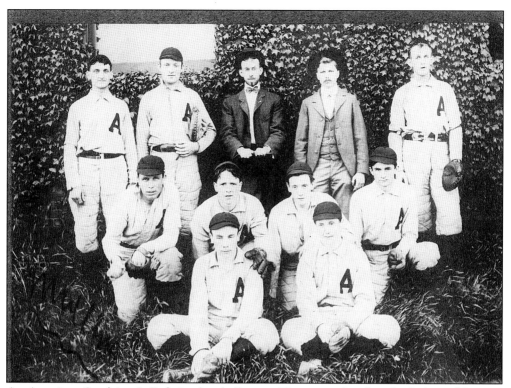

An American Smelting & Refining baseball team. This team played in the Industrial League. General Cable played in this league as well.

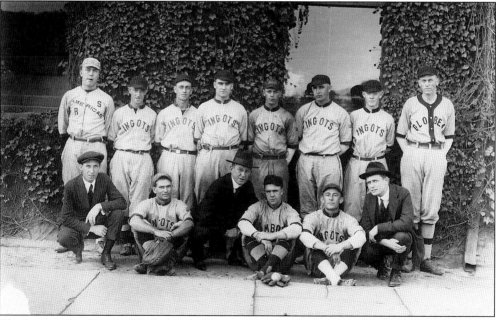

The Ingots, the Copper Works baseball team. The Raritan Copper Works sponsored baseball teams that competed against teams from other Perth Amboy and Middlesex County industries in the Industrial League. John Deak is third from the right in the back row.

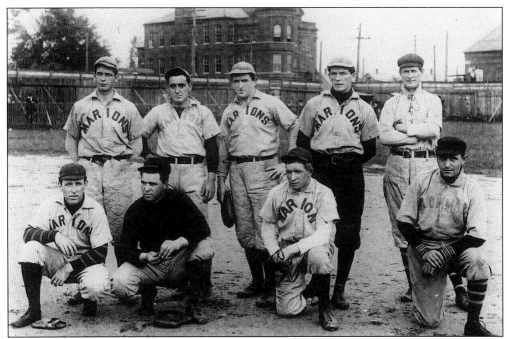

The Marions. Some of the "factory leagues" launched workers into semi-professional baseball. All the members of this baseball team—except for Mr. Connolly and Mr. Galvin—went professional. Mr. Galvin is in the front row, second from the left. School No. 4 is in the background.

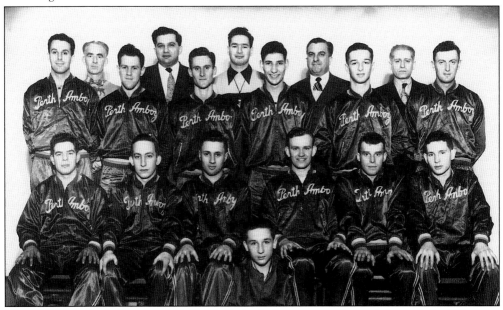

The YMHA basketball team of 1949–50. Basketball was a popular activity and the "Y" teams were community champions. From left to right are: (front row) Buddy Ewert, Victor Diamond, and Dave Hutter; (second row) Artie Sinetsky, Eddie Turtletaub, and Irving Rubinoff; (third row) Lenny Thomas, Hecky Plain, Marvin Mankowitz, Hy Koch, and Eddie Meyers; (back row) Mr. Fox, Sam Cohen, Al Katz, and Irving Goldmintz.

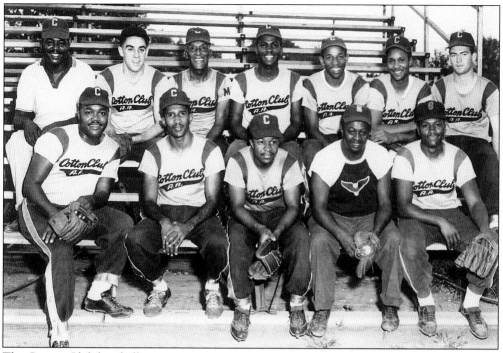

The Cotton Club baseball team.

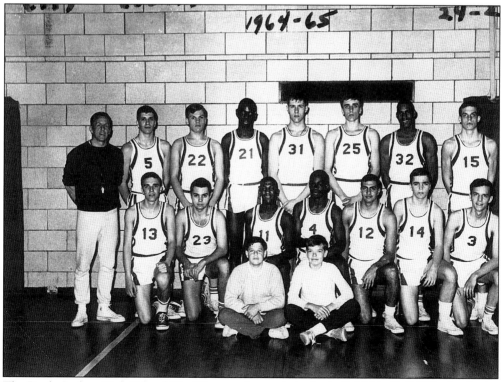

The Perth Amboy High School City/County champs in basketball, 1964–65. Bill Buglovsky (at left) was the coach

The opening of the Victory Bridge, 1926. The bridge was dedicated to the men and women who had lost their lives in World War I. It was meant to link the southern and central parts of New Jersey with the Perth Amboy-Tottenville ferry. Record-breaking automobile sales put so many vehicles on the road that one of the worst traffic jams in Perth Amboy's history took place soon after the bridge opened.

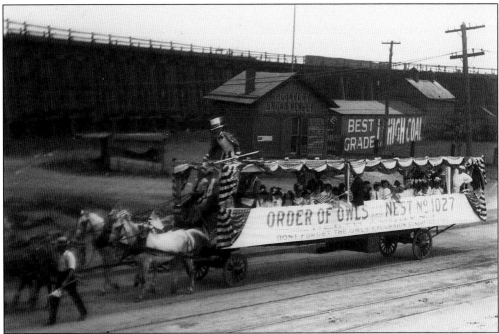

An Order of Owls float, 1910. The people of Perth Amboy bonded in many societies, associations, fraternal organizations, clubs, singing groups, mandolin clubs, labor organizations, business organizations, and military posts. Nest No. 1027 met on the second and fourth Fridays at Eagle's Hall.

The Victory Bridge opening, 1926. Lieutenant Commander Lewis Compton was in charge of the dedication day parade. Mayor William Wilson was the general chair of the many events connected with the opening. By 1936, the Victory Bridge was unable to handle the necessary traffic and the Edison Bridge was built. The Victory Bridge's function returned to that of the old wooden bridge it had replaced, handling mostly local traffic and joining South and Perth Amboy.

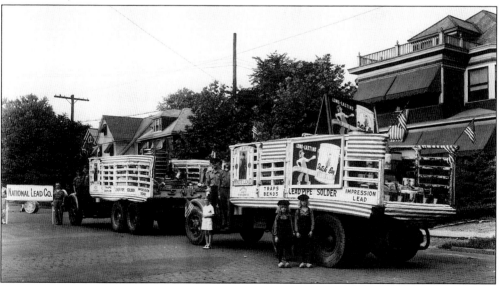

A National Lead float. Before any environmental concerns surfaced, National Lead made lead pipe, solder, and plumbing traps. The still-famous Dutch Boy Paints made here were known the world over. Two Perth Amboyans—dressed as the company's trademarks—were participants in one of the city's many parades.

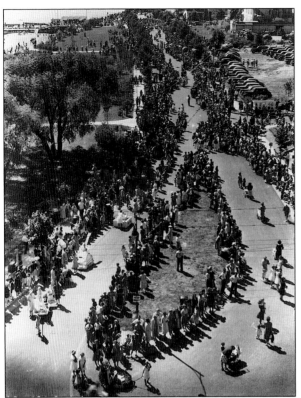

The First Annual Baby Parade, August 13, 1941. Perth Amboy had spectacular parades celebrating events, organizations, and themes with elaborate floats, marching bands, and strong organizational representation. Parents carried, pushed, and pulled their little ones on Southern Parkway, now Sadowski Parkway, during this event. Research does not reveal the winning baby nor the existence of a Second Annual Baby Parade.

An early automobile full of spectators for Victory Bridge opening, 1926. Trolley tracks were included in the early plans for the bridge. However, the bridge was built ten years after the contract was first submitted to the board of freeholders and by that time the Raritan Traction Company was out of business. As a result, the new bridge did not have trolley tracks.

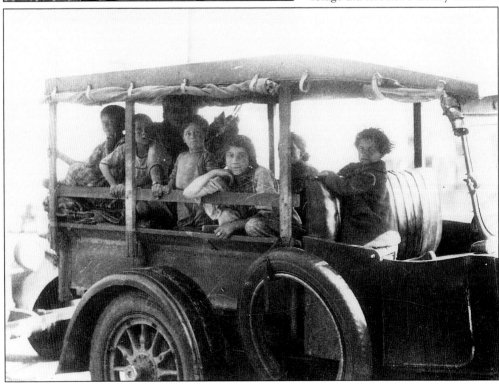

Five

LOST PERTH AMBOY

More has been lost to fire and indifference than to obsolescence

The Congregation Shaarey Tefiloh (Gates of Prayer) Synagogue, *c.* 1951. A group of men from the Hebrew Mutual Aid Society organized a new congregation that built this synagogue at 314 Madison Avenue. It was opened for the 1903 High Holy Days and dedicated in a memorable parade. The building was later destroyed by fire.

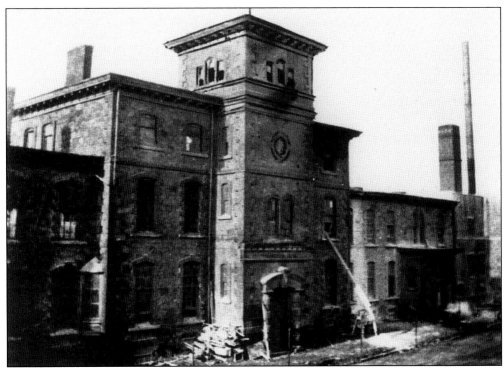

A last look at Eagleswood, 1936. This was the phalanx at the Raritan Bay Union, a utopian community in the Eagleswood section. During the years before the Civil War, it was the cultural center of the area. Its 227 acres were surveyed by Henry David Thoreau, who read his essays to children at the innovative school. Abolitionists, early womens' rights activists, famous artists, and writers found a home here amidst the gardens. It was used by the C. Pardee Tile Works for a short time and was demolished in 1936.

The C. Pardee Tile Works. Structurally, the phalanx lived on during the Pardee occupancy. The brownstone building with the residents' quarters in the wings can be seen in the background.

George Innes' studio, 1865–68. The famous landscape artist George Innes lived and worked in a studio at the corner of Convery Boulevard and Smith Street. This residence was built for him by Marcus Spring, generally credited as the founder of Eagleswood. *Peace and Plenty*, a work now in the Metropolitan Museum of Art, was created by Innes as a repayment for Spring. The house was razed overnight a few years ago.

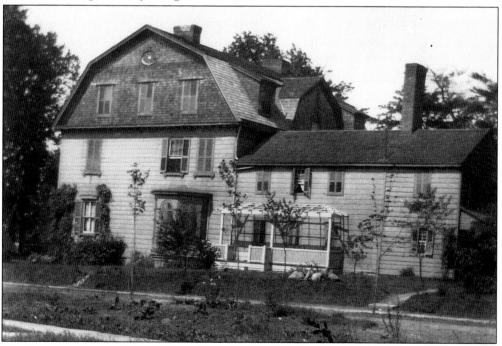

The Patterson House. Judge William Patterson lived in this grand house on Kearny Avenue. It was also known as Andrew Bell's house because he lived there for many years.

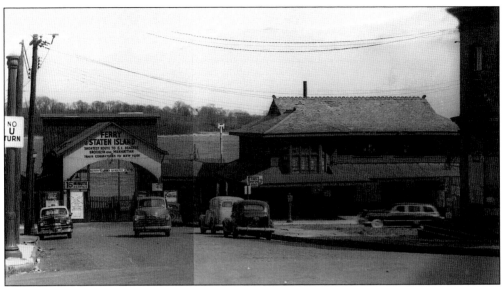

The Perth Amboy to Tottenville ferry, 1951. This was the introduction to Perth Amboy for immigrants from Ellis Island. They were told Perth Amboy was a place to find work, and if they had no destination, they traveled across Staten Island by train and made their new homes here. Waiting for the ferry is the Booz Engineering truck and Tom "Bruce" Sinatra's car.

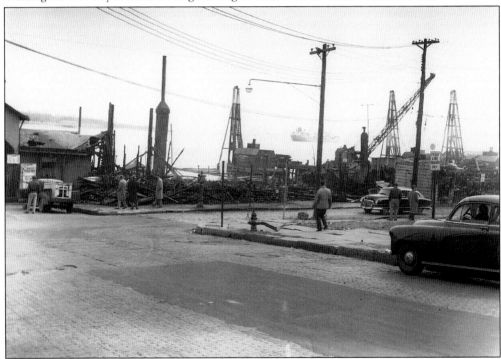

The ferry after the fire. Probably everyone's strongest association with Perth Amboy is the ferry and the ticket house. Here passengers bought their tickets and perhaps also something to snack on while they waited for the departure. In a disastrous fire, the ferry house burned to the ground. Only the slip remains. WATER, a group organized to restore the waterfront, is working to rehabilitate this historic structure.

Saint Mary's School. Saint Mary's School was built on the grounds of the present church rectory in a wooden frame building that was 25 feet tall and cost $400. Saint Mary's School on Center Street was built twenty years before the first public school building.

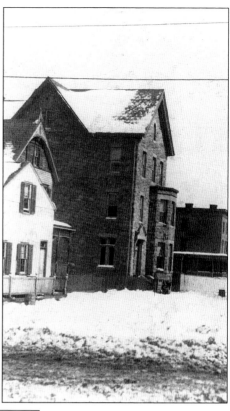

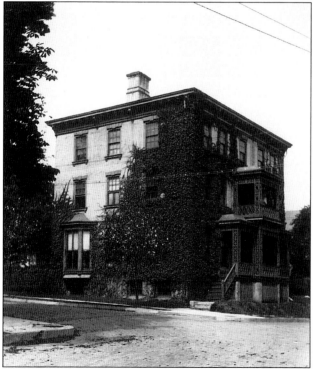

The Raritan House. Originally this ivy-covered structure was built as a two-story house in the 1760s. It was a hotel in the nineteenth century. A third story was added during the Civil War.

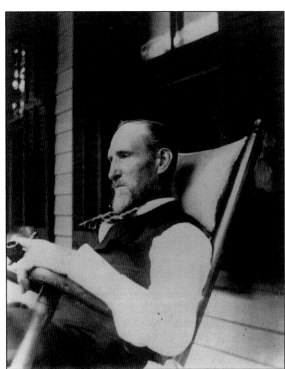

James Camille Rossi. Mr. Rossi had the first telephone number in Perth Amboy—0001. This marked the beginning of a new era.

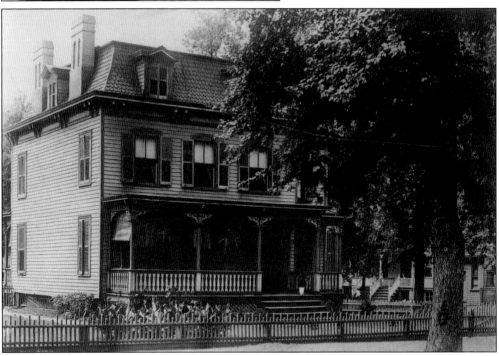

The Rossi House. Mr. Rossi's house was at the corner of Lewis and Catalpa Streets, but it is no longer there. Much of historic Perth Amboy has disappeared, but its memory and the foundation for life that it gave to many of us still exist. What do we make of what we know and what we remember and what can never be replaced?